5-95

about
70
photographs

about 70 photographs

Edited by Chris Steele-Perkins Commentaries by Chris Steele-Perkins and William Messer

Arts Council of Great Britain

About 70 Photographs

Edited by Chris Steele-Perkins

© 1980 Arts Council of Great Britain
Introduction © Chris Steele-Perkins
Commentaries © Chris Steele-Perkins and William Messer
Acknowledgments appear opposite

Designed by Alan Stewart
Production Management by Travelling Light, London
Typesetting by Opus Photo, London
Printed by John S. Speight Ltd., Leeds
Distributed by A. Zwemmer Ltd., 26 Litchfield Street, London WC2H 9NJ

British Library Cataloguing in Publication Data
About 70 Photographs
 1. Arts Council of Great Britain
 2. Photography – Great Britain – History – 20th century
 3. Photography, Artistic – History – 20th century
 4. Steele-Perkins, Chris II. Messer, William III. Arts Council of Great Britain
 779'.0941 TR654

ISBN 0-7287-0209-6 Hard cover
ISBN 0-7287-0208-8 Soft cover

A list of Arts Council publications, including all exhibition catalogues in print, can be obtained from the Publications Department, Arts Council of Great Britain, 105 Piccadilly, London W1V 0AU

Notes for the Introduction are listed on page 145 and the text notes are on pages 145 to 147

Acknowledgments

We thank the following people for their help in the realisation of this book:

Nina Kelgren and David Hoffman for essential picture research;
Heather Forbes and Peter Turner who co-ordinated production;
Alan Stewart for the design;
Averil Ashfield who sub-edited the text;
Roy Kift, Richard Smith, Valerie Lloyd, Peter Turner, Colin Osman, David, Hoffman, Stevie Bezencenet and Mark Haworth-Booth for comment and criticism;
the Photography Committee of the Arts Council of Great Britain, David Hurn for providing the opportunity and especially Mark Haworth-Booth for having sufficient faith to support the idea from its conception;
Claus Henning, Director of General Exhibitions at the British Council, for timely enthusiasm and undertaking to produce an exhibition based on this book;
many friends and colleagues for their encouragement and suggestions;
each other, from whom we have learned appreciably.

There is also a generic debt, in kind and spirit, owed to numerous individuals for their influence and example prior to this book's conception. Along with those neglected by fuzzy memories, they are Mark Edwards, John Szarkowski, Nathan Lyons, Bill Jay, Bill Brandt, Robert Frank, Ralph Gibson, Larry Sultan, Mike Mandel and the photographers themselves, whose work provided stimulation and reward throughout our efforts to present it.

Chris Steele-Perkins and William Messer
March 1980, London

Introduction

The selection of photographs in this book is intended to delight, provoke, disturb, entertain and stimulate. The accompanying commentaries have been written to further such responses.

All these photographs are represented in the collection of the Arts Council of Great Britain, but they do not reflect the overall balance of that collection as many of them have been specifically purchased for this book from areas of practice previously outside the Arts Council's frame of reference. This is because a great deal of interesting photography is, and always has been, done by people who work outside the practice of art. Indeed it is precisely the inter-relationship between the functional and artistic traditions in photography that makes it such a vital and potent medium.

An examination of the history of photography reveals a curious avant garde of technology, artists and journeymen photographers. Technological advances such as miniature cameras, more sophisticated lenses, increasingly sensitive emulsions, colour films, instant development and electronic flash have continually opened up the medium for practising photographers. Its art history is studded with photographs and photographers innocent of artistic intention. Later they were 'recognised' and annexed to that history. The contribution of such photographers as John Thomson, Eadweard Muybridge, Eugene Atget, Jacob Riis, Jacques Henri Lartigue, Weegee, Robert Capa and Dr Harold Edgerton is enormous. Their initial motivations were many and various: scientific research, providing documentary illustrations for painters, social reform, childhood enthusiasm, and photographing for newspaper and magazine stories.

The importance of the functional tradition in photography was recognised and massively celebrated in the 1929 German exhibition, *Film und Foto*, a venture which filled 14 galleries. The director, Gustaf Stotz, stated at the time, 'the results that can be obtained uniquely by these new photographic means have been published here and there but never systematically compiled The fields that will be investigated are extensive. To name a few: news photographs in the widest sense including sports shots, war pictures, night exposures, criminological photographs. Further: scientific photographs–zoological, botanical, medical (X-rays)–photomicrographs, aerial views, studies of the structure of materials. Then the area of light made form-giving by artificial sources, some with lenses, others directly on light-sensitive paper (photograms); the superimposition of several photographs; the use of photography in the graphic arts and advertising (photomontage and phototypography).'[1] In addition to these images the work of well-known photographers, including Edward and Brett Weston, Man Ray, Moholy-Nagy, Edward Steichen, Charles Sheeler and John Heartfield was exhibited.

More recently it is in the USA that functional photography continues to be explored.

In 1966 John Szarkowski edited *The Photographer's Eye*[2] which investigated aesthetic values in photography by drawing upon an eclectic selection of photographs. In it he stated, 'The study of photographic

form must consider the medium's "Fine Art" tradition and its "Functional" tradition as intimately interdependent aspects of a single history . . . the vision they share belongs to no school of aesthetic theory, but to photography itself.[2]

Szarkowski also edited *From the Picture Press*[3] which examined the more specific, and generally maligned, area of press photography.

In another vein Andrew Lanyon's *Snap*,[4] and Ken Graves's and Mitchell Payne's *American Snapshots*,[5] distilled fascinating collections of imagery from an area of practice which has usually been examined for its historical, rather than aesthetic, significance.

In 1977 Mike Mandel and Larry Sultan compiled *Evidence*,[6] a strange and confounding selection of uncaptioned images culled from the files of government agencies, educational institutions and commercial corporations. While these images challenge the imagination in a way far removed from their initial purpose of recording, the selection of American studio photographers' work in Barbara P. Norfleet's *The Champion Pig*[7] underlines the remarkable documentary vision of some of those professional practitioners.

The virtually limitless production of photographs provides enormous problems of research and editing, but once explored this great mass of imagery proves to be a goldmine, sociologically, historically and artistically. With the exception of *The Photographer's Eye*, each of these books mentioned mines a particular vein of photographic practice, representing it in the light of a contemporary understanding of the medium. *About 70 Photographs* samples a broad span of recent British photographic practice. The core of the book is reportage and social documentary photography, reflecting the dominant thrust of the medium in Britain, as well as my own bias. Around this core are photographs ranging from fine art to nuclear physics, advertising to medicine. I regret that I have not had the time or finance to draw upon an even more eclectic range of imagery, and that another significant area for investigation – sets, series and sequences of photographs as well as photograph-text combinations – has only been touched upon. These require a book to themselves and I hope that somebody will take the trouble to make one.

I recognise a difficulty, when presenting individual photographic images removed from their initial context, in seeming to imply that this is the *right* way to consider them; this is not intended. An awareness of original context is often important and is one service the accompanying texts here can provide. However, these pictures go beyond mere illustration and reward examination in a wider framework of photography, where they succeed as singular photographs.

I am tremendously excited to present these pictures, feeling like a photographic disc-jockey about to uncork a set of images which'll grab you by the eye-balls and turn your head around.

Chris Steele-Perkins, January 1980

This photograph could have been made simply by casting a handful of sand on a piece of photographic paper and exposing it to light. What it would represent are those grains of sand, the act of dropping them upon the paper and the chemical reactions of the emulsion with the light, developer and fixer (represented here by a mechanical reproduction in ink). It may also be a design, a mistake, a mandala, a headlamp in snow or the centre of the universe. It is, to some extent, up to us. The same is true of all photographs, though we tend to be content with what they *apparently* represent, which usually seems obvious to us: a tree, a building, a person, a dog. Depending on what else we may know, these can be a Larch (Larix decidua) in the botanical garden at Kew, the Empire State Building (1,472 foot tall) or Aunt Mable and her poodle (now dead).

With some photographs we do not need more than they give us visibly; they are sufficiently recognizable and satisfying. But through the ambiguities of photographic reality, the unfamiliarity of subject matter and its methods of presentation and our own jumping to conclusions, many photographs require supplementary information to unfold their meanings.

This data may come in the form of titles, captions and text in publications, statements of intention, lectures and critical reviews accompanying exhibitions or spoken commentary with snapshot wallets and family photo albums. Sometimes the information is so extraordinary as to transform what we see into something we hardly believe, or only dimly comprehend.

w Centauri is the name for a large and very dense group of several million stars, each of a mass comparable to that of our Sun, some 15,000 light-years into space. A 'globular cluster' it appears to the naked eye as a rather weak, watery-looking star in the constellation Centaurius in the Southern Hemisphere. In fact it is an intensely bright object, with some of its stars only light-hours apart! An estimated 500 globular clusters form the 'halo' of our galaxy, in orbits of several hundred million years.

Deeper in space, galaxies themselves are clustered in hundreds and thousands. Probably a thousand million galaxies fall within the extreme range of Earth-mounted telescopes, at distances as great as many billion light-years.

ANGLO AUSTRALIAN OBSERVATORY

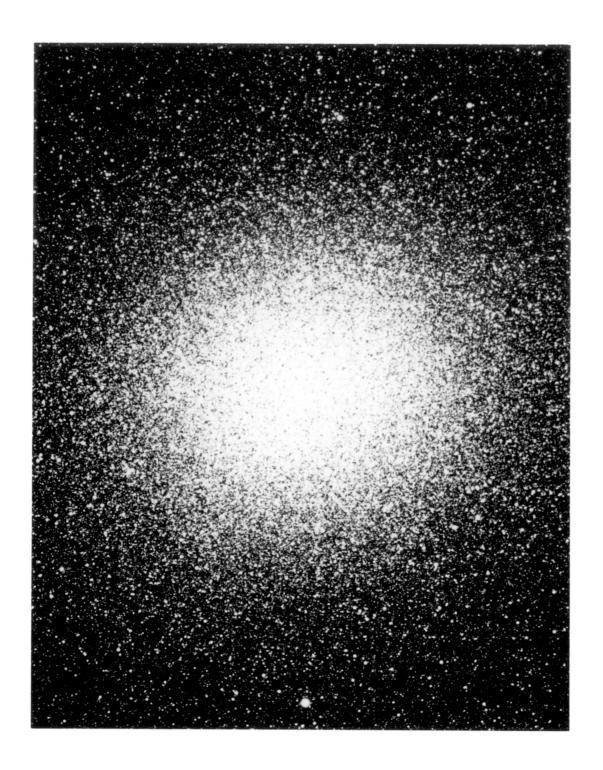

After the early successes of the Industrial Revolution, God, effectively, had gears and spirituality went into liquidation. Man behaved as if he believed only in man, what he could make and what he could see. Photography was a technological triumph of man's belief, a creation confirming the evidential world of his reasonable senses. But almost from the start this invention of Science was besieged by those who would claim for it mysterious capabilities. The camera-artist was in the bewildering situation of being both recipient of the new analytical sophistication and a cultural repository for the diminishing roles of magician, minister and mystic; inheritor of the powers of Intuition and Inspiration.

'The photographic image itself has great magical possibilities. Like the ceremonial mask, the ritual incantation, the protective amulet, or magical mandala, the photograph has the potency of releasing in the viewer preconditioned reactions that cause him to physically change or be mentally transformed. In fact . . . it can provoke even stronger reactions than other graphic media.

The magical photograph is simply one that attempts, by its mere assertive presence, to go beyond the immediate context of the recorded experience into realms of the undefinable. The photographer as magician is just someone who is acutely aware of the subliminal "vibrations" of the everyday world which can call forth hidden emotions or states of feeling that are usually tightly wrapped up in our unconscious selves. He is totally opened to the multiplicities of associations that are submerged behind the appearances of the objective world. He uses the repressed mythology of dreams and the archetypal designs of geometry to magically conjure up deep and irrational reactions from the viewer.'[1]

Jim Harold's photograph with its four cornered division and dark central rectangle into which the surrounding lines converge approximates to the form of a mandala.[2] The eminent Swiss psychologist C. G. Jung, whose work investigated the world of dreams and the archetypes and symbols that communicate the human unconscious, identified a quadrangular form of mandala as representing a conscious realization of psychic wholeness, symbolising the body and physical reality. The Navaho Indian employs mandalas in medicine to restore inner balance, the Hindus to consolidate inner being. They are commonly used to deepen meditation. Jung explains that the mandala was originally used, 'to clarify the nature of the deity philosophically. In the centre . . . we usually find the deity. It is evident that in the modern mandala, man – the complete man – has replaced the deity.'[3]

The photograph is receptive to Jungian reading. An unidentified woman whose body supports the central square of the mandala stands in our path. She may be seen as the 'anima', the female element of the male psyche, the 'inner figure' of feeling, personal love, non-rationality, intuition, a link to nature and positive mediator between the ego and the Self. If the anima is to serve as an effective guide to the 'inner world' she must neither be too generalized nor exclusively personal.[4]

Every personification of the unconscious – including the anima – has both a positive and negative, light and dark side. Psychologically, left represents the unadapted instinct while right indicates awareness and adaptation. Here the figure divides the landscape into day and night.

Jim Harold does not contradict these interpretations of his work, which he says is '. . . a direct intuitive response to internal and external stimulation. Initially I was interested only in the physical environment, the surface manifestations of both the human and natural world . . . Now, I am beginning, tentatively, to realize a less strictly orientated world, one in which outlines blur and objects and events cease to exist in isolation, a world of complex interaction, where the surface is only one small part of what there is to discover. I am now beginning to explore the mystery of these moments . . .'[5]

JIM HAROLD 1976

12 YOUNG BOY

When a photograph is made with a large-format camera there is prescribed a carefully layered ritual of cloth, inversion, and dark-slide. The picture unfolds under cover, viewable only right-to-left and upside down; for several seconds on either side of the shutter's release it is invisible altogether. The process is both approximate and exacting, capable of greatest precision only when the subject matter does not move. There is, therefore, a feeling of stillness to be found in much large-format work which, in the best examples, is much more than a sense of something being stilled.

John Myers' photograph of a young boy in a yard with his football is full of these qualities of large camera seeing. Even the air seems motionless for the moment when the picture was taken. In the grey, shadowless light the boy is picked out in sharp focus within the diffuse background, the edge lines of his shirt, hair and cheeks holding his upper body in relief against the smooth, studio-like surface of the concrete wall behind him. The effect is like that of a cut-out figure, which recedes as our eye drops to his football and shoes, their round softness attesting to their ownership by the round-headed, soft-featured boy. In an almost subliminal play of straight-edged geometrical forms, the pattern on the ball is echoed across the gradually diffusing paving stones, the bricks, the trellis work, and in the cellular quality of the picture overall. This repetition is concentrated in the boy's shirt, where it again becomes sharp and reconnected to him.

Attachment, isolation, separation, connection: these are the durable themes being worked here through the visible phrasings of round, flat, soft, sharp, light, dark. It is a subtle, quiet thing, probably partly unconscious – still, it works.

JOHN MYERS 1975

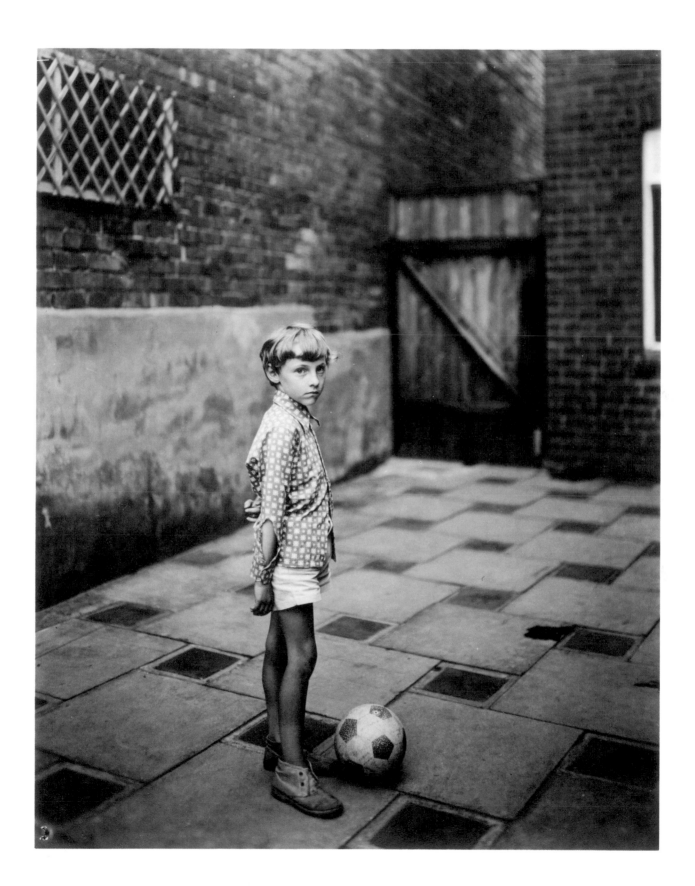

George Cole is an actor and – as such – like a photograph. As an actor does, so must a photograph create a tangible, apparently recognizable representation of something apart from itself: this may be an idea, an emotion, a specific person, event or image. Its vehicles are imitation and illusion. Both the actor and the photographer perform, or attempt to, for an audience who may perceive them as anything from windows on to the world of actual appearances to mirrors of the playwright's or photographer's intended meaning.[1] One must believe in both their semblance and sense for their success, and one must be susceptible to some degree of confusion.

The celebrated American photographer, Richard Avedon, who has photographed many actors and models, once defined the photographic portrait as 'a picture of someone who knows he's being photographed'; continuing the analogy, the actor can be viewed as a photograph which knows it is being someone.

Just as the right photograph can appear to lend depth to an individual's character, the mirror provides confirmation of an actor's range. In the mirror the actor tests his mask. And should the rituals of transformation into and out of role after role, night after night, ever leave him confused and uncertain as to just who he might be, the actor can again make his passage to his dressing-room table to consult the mirror for evidence that all is well – he is himself, George Cole, actor.

BRIAN GRIFFIN 1977

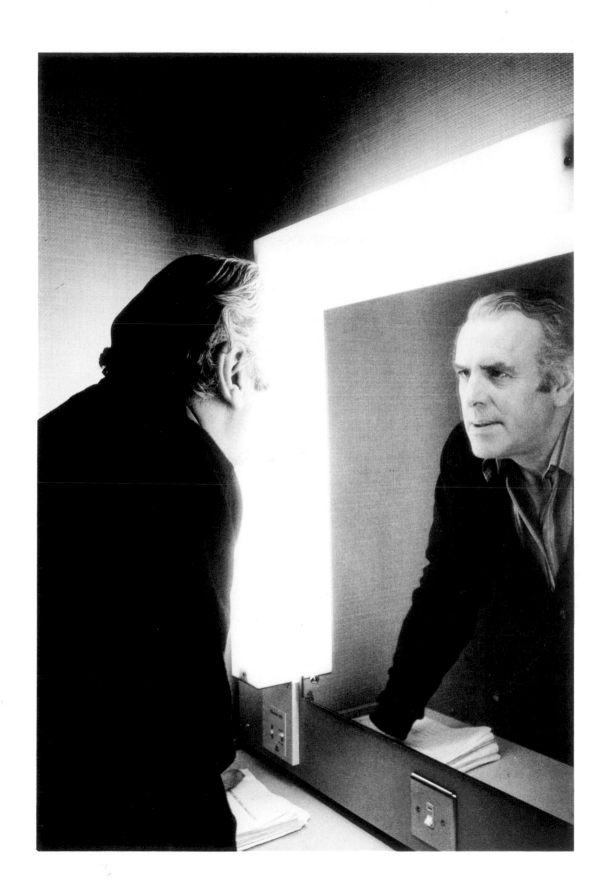

Strange and marvellous events, scientific experiments. Facts. Photographic Proof! Transformational Mystery and mechanical theatre of the Conditional Probability Machine.[1] The IMPACT RIG! SEE the Truncated Silver Surfer forever suspended from rightful union with the Steering Wheel but what are we really shown?

This is a publicity photograph made to demonstrate equipment for testing whether or not steering wheels are strong enough to meet safety standards – the illusion of forward movement was created by pulling the dummy backwards during a time-exposure. Knowing this in no way diminishes the photograph's impact.

ANDREW M. ANDERSON 1972

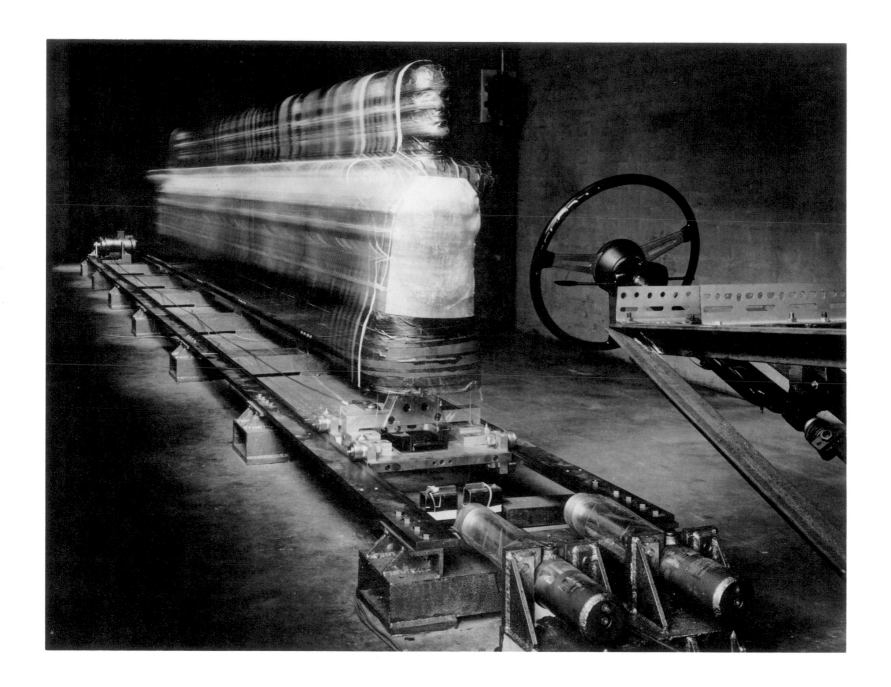

When hard news is difficult to come by, titilation and publicity stunts are always there to fall back upon. Or so the *Daily Mail* must have thought when stripper Cher Wood called to announce her intention to go to Eton – that most respectable of English educational institutions for the over-privileged, on whose magical playing-fields the fates of nations have allegedly been decided – to protest, in her thoroughly professional capacity, the school's discrimination against girl pupils.

No doubt Cher felt deeply about this issue and exposing it was not going to do her career any harm either. In the best of Public School responses to private parts in public places, the boys remain erect and snigger. It is, after all, an awfully good show; but not quite enough for the *Daily Mail* who, at the end of the day, found a hard news photograph to bump Cher off the page. Eventually she turned up in the *Photography Year Book*.

The picture itself offers much. The boys, costumed in their symbols of male upper-class breeding, education and money – surrogate adults – are confronted by an act which suggests availability, vulnerability, but is neither. It is a confident, defiant gesture made by a full-grown female, secure, if in nothing else, in this one power over them. But this is not a power that lasts: she will age, and they will learn to suppress its importance.

MIKE HOLLIST 1976

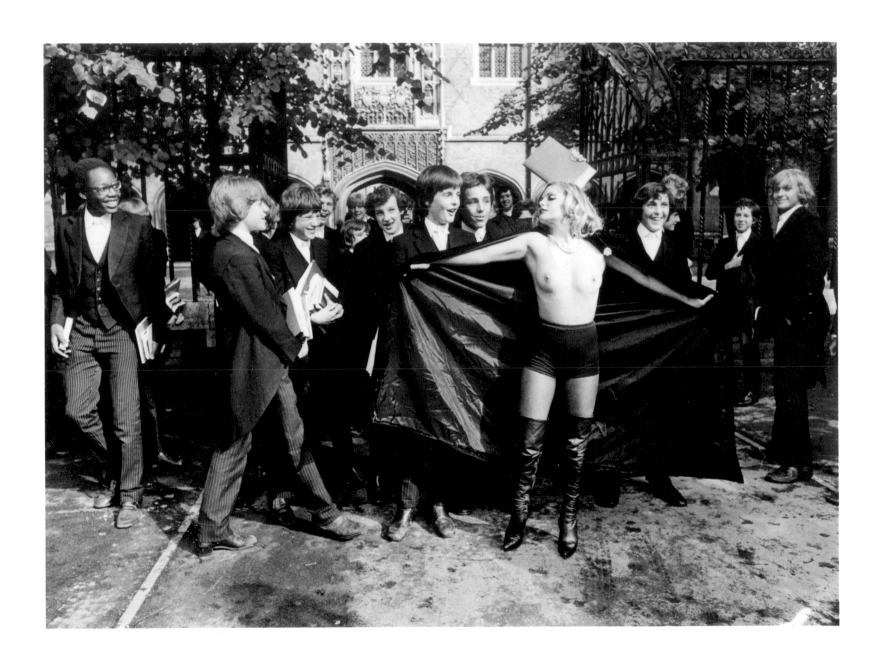

20 EIRE

The house at the end of the village, an outpost of white walls, dog and a tattered flag, where the road curves into the hills. The open gate offers the traveller the last opportunity for a cup of afternoon tea or the last chance for a bed at night.
 It is a carefully made photograph, resolving its elements in a thoroughly satisfying way. There is no tension; a quiet, stilled space, which allows you to enter if you wish and then seduces you with its eloquence.

RAYMOND MOORE 1971

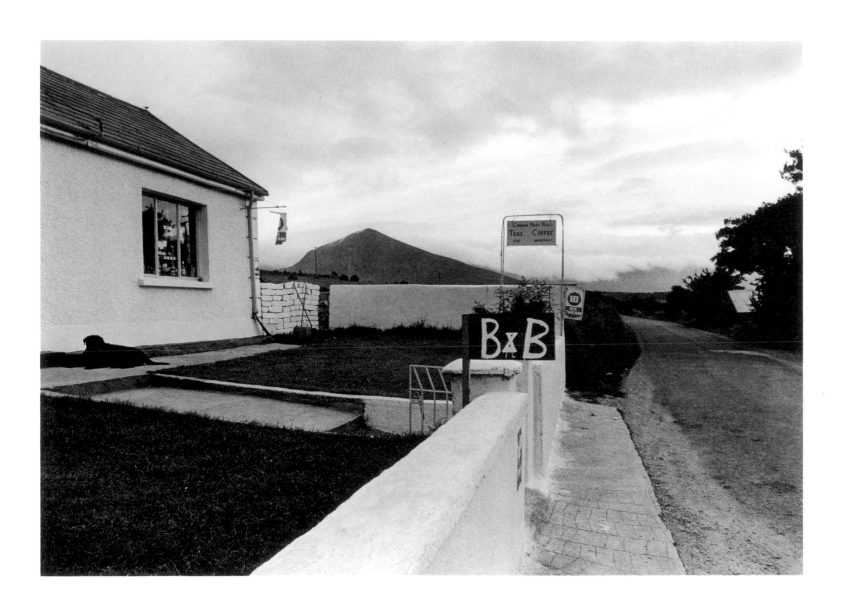

Throughout the history of the medium, photographers have talked in terms of being responsible to, respecting, celebrating, being true to their subject, and of photography as a kind of hommage and a way of life.

Not unlike praying, taking a photograph, may be a perfunctory gesture, an empty ritual, or a profoundly important and meaningful act, a quest for understanding.

These three men have made a pilgrimage in order to pray on rocky ground in a high place. The photographer has come to the same place in order to photograph them. Even if he does not share their particular religious beliefs, a strong affinity is communicated to us.

JOSEF KOUDELKA 1974

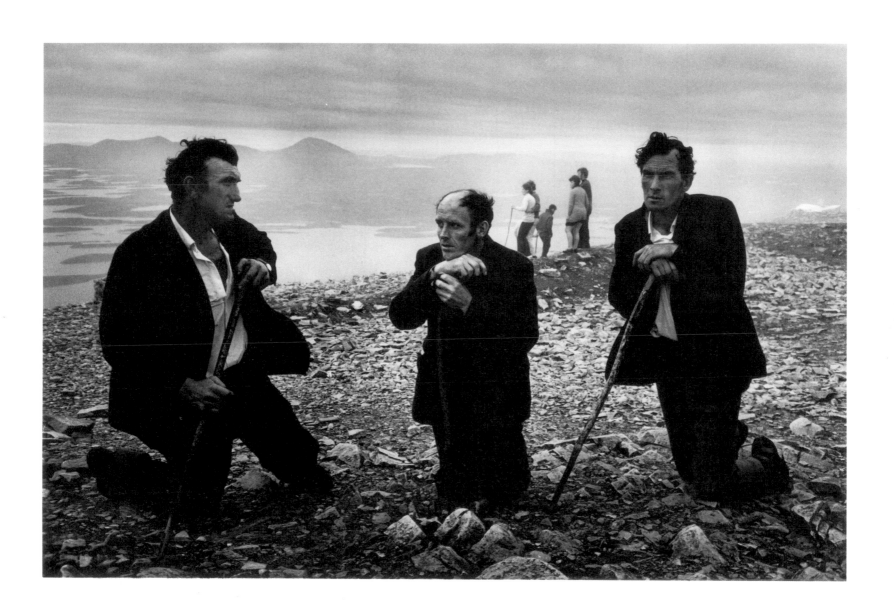

The elements in this photograph are so clearly and incongruously displayed, their cultural meanings so pervasive that we have only to lift them out of the picture with our eyes – a classic news photograph, waiting only for the words to identify the specific who? where? when? why? etc of the event.

The man in a holy state of disrobement is a 25 year old accountant whose name was not reported. He is at Twickenham for a rugby match between England and France. It is half-time on Saturday, 20 April 1974. The man hurrying forward with a raincoat, whom Harold Evans of *The Sunday Times* referred to as 'a matador of modesty,'[1] is Mr Grundy, an official. Princess Alexandra is in the Royal Box.

Why this occurred was not reported either, presumably because 'streaking' had become a well publicised phenomenon requiring no particular explanation. An internationally televised rugby match with royalty in attendance is the raw material for sensational streaking. In this instance it also presented the national press with a rare opportunity for a scoop, as the TV camera operators were taking a half-time break when the 'Twickenham Streaker' – as the photograph has come to be known – made his unscheduled appearance.

The *Sunday Mirror* ran the picture full-width across the front page. The French were even more delighted (they won the match) and used it as a centrespread in *Paris Match*, displaying it open on the bookstands. Since then the photograph continues to reappear in books and conversations, and recently, on the television quiz programme 'Celebrity Squares', it was used to advance an historical explanation for the distinctive shape of the English Bobby's helmet.

IAN BRADSHAW 1974

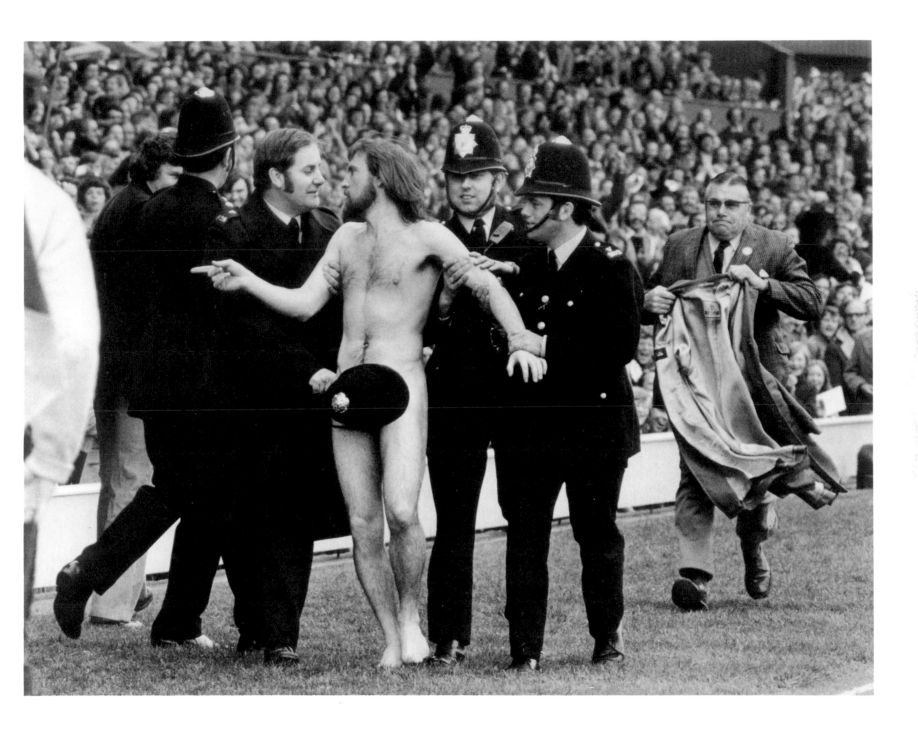

Reportage photography generally involves the portraying of socially determined, transient events, often at close range and in such a manner that the *events* themselves may well outweigh the *picture's* contribution to the photograph's meaning. In the natural landscape, the shaping events are less socially than culturally and geologically determined, their occurrence is both more gradual and more continuous than those which normally comprise reportage subject-matter. In addition, a landscape is usually seen at a distance, requiring minimal adjustments in focus or parallax for the eyes; like a projection, it is received as nearly flat and fixed – virtually a pre-formed picture. For a medium so reliant on the actual forms of the visible world, photography is provided by the landscape with a natural stepping-stone towards contemplative viewing and recognition as a picture-making medium, beyond its basic role in recording – a building-block for its fuller understanding and appreciation.

When photography burst upon the unsuspecting world in the middle of the 19th century, much of what was known and believed about the land was owed specifically to established traditions of landscape painting and printmaking, whose familiar forms and conventions stood ready to serve the camera-carrier as well. But the issue of photography's status as a visual art raised the challenging question of creativity: who created photography's pictures, since it seemed the sun had *made* them while the photographer had only to *take* them? In arranging still-lifes or studio portraits some photographers perhaps found slightly firmer ground for asserting their claims as Artists, but a rapidly growing army of less pretentious photographers were busily engaged in photographing everything, everywhere '. . . under almost every condition, without ever pausing to ask themselves, is this or that artistic?'[1] and, in the process, discovering a new aesthetic and language, inventing new value systems as they went along.

However, when photographers turned more formally towards the natural landscape they faced a problem. Here they were recording Nature with a capital 'N', the actual handiwork of God and Perfection wherever it was found. Traditional artists struggled with their craft to be faithful to this perfection; but the camera was felt to have overcome the problems of representation in the single action of exposure. The photograph of Nature was seen as Nature herself, drawing her own portrait with light. How could such a perfect reflection of Nature be itself anything less than perfect? This much maligned mechanical picture-making system, partly severed from a valued association with Fine Art, by recording the landscape was elevated into the most intimate relationship with the very inspiration and source of all art and creativity. Inaccuracy or alteration must have amounted to sacrilege – yet both would become principal instruments for reasserting the photographer-artist's 'creative' validity in historical and critical eyes. Is there any wonder so much confusion and resentment surrounded the new medium, seen as too special by nature, and too easily done to merit that specialness?

Curiously, with the passage of time, the place of the landscape in British photography has not been too certain, continuing to attract photographers but never fully establishing itself as a tradition.[2] It has only been with the recent revival of interest in the medium itself and the influence of new conceptual landscape and 'topographical' work being done elsewhere that the camera's look at the land has again received substantial acknowledgement and esteem in Britain, with fullest endorsement coming in the form of a massive exhibition at the Victoria and Albert Museum in 1975, *The Land*.[3]

Of course, other factors outside the medium and fine art generally have been influential in British photography's return to the landscape. Doubtless the ever-increasing intensity and concentration of modern urban life have made the countryside more attractive, while less available. And, perhaps critically, in the ways in which the photograph serves to 'preserve' what it pictures, the photographing of the natural landscape suits the growing world-wide concern for ecological conservation and survival.

For several years John Davies has been studying the natural water cycle on and over the land, often going to the west coast of Ireland for his images. One senses that he understands and has satisfied the essential requisites for the photographer of nature stated by poet, photographer and editor Jonathan Williams in his catalogue introduction for *The Land*, 'to realise that the photographer, like any maker, faces his own nature first, then works out from there, clicking the shutter at what he alone sees'.

JOHN A. DAVIES 1976

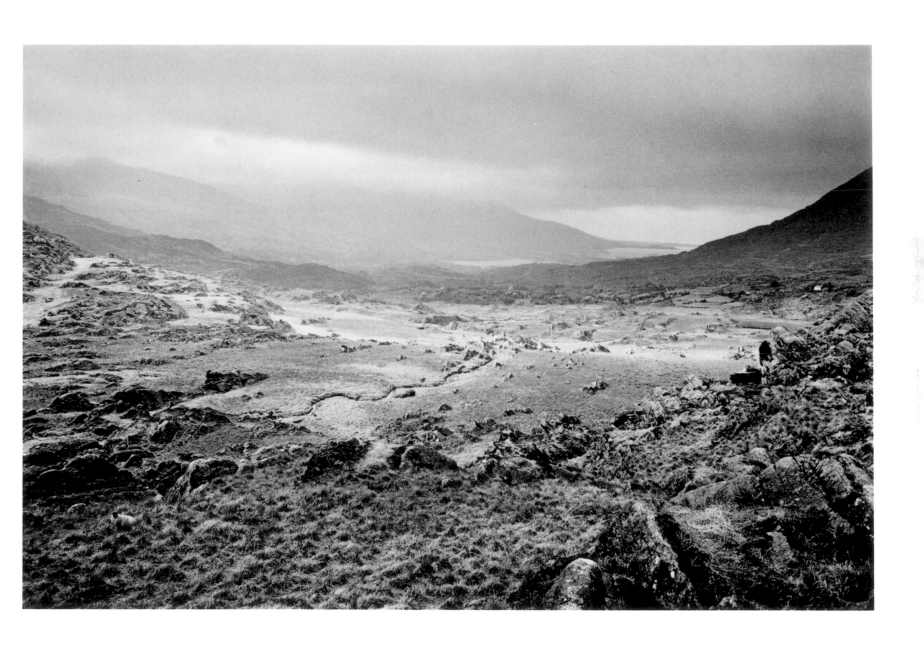

'Seen nearer, the thing was incredibly strange, for it was no mere insensate machine . . . and the brazen hood that surmounted it moved to and fro with the inevitable suggestion of a head looking about it . . .'

'I looked up and saw the lower surface . . . coming across the hole . . . I stood petrified, staring. Then I saw through a sort of glass plate near the edge of the body the face, as we may call it, and the large dark eyes of a Martian peering . . .'

The red insides of the detonation chamber conceal the 'interior source' suspended into its centre and a sooted plate for recording the structure of the advancing detonation. The alien mask of Technology with its sad slit of a mouth and single useful eye is revealed a science fact in which man is not defined as controller, passenger or prisoner.

'The shell burst clean in the face of the thing. The hood bulged, flashed, was whirled off in a dozen tattered fragments of glittering metal . . . The living intelligence, the Martian within the hood, was slain and splashed to the four winds of heaven, and the thing was now but a mere intricate device of metal whirling to destruction . . . incapable of guidance . . . it blundered on and collapsed with a tremendous impact . . .'[1]

DON WILLIAMS 1977

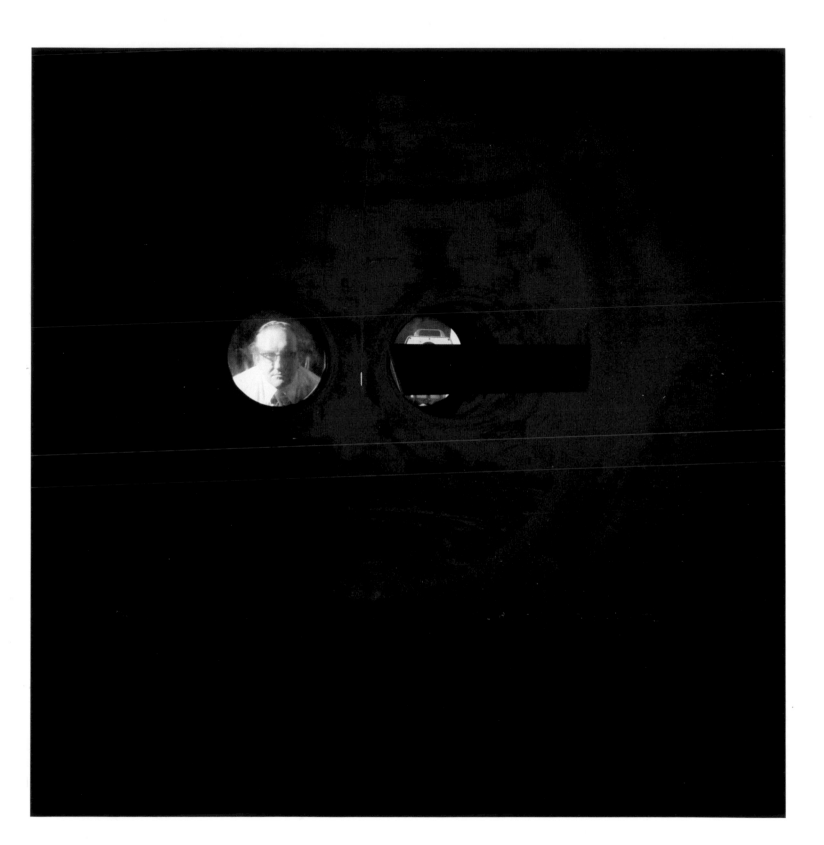

FOUND PHOTO

Portrait photography has come a long way from the days when it was a lengthy, expensive privilege necessitating a studio and highly skilled photographer. The photo booth now provides a fast, cheap service, widely available in stations, stores and city streets, and operable by anyone.

The booth's curtain allows sufficient privacy for attention to appearance, adjusting the hair, checking make-up, preparing a confident stare or warm smile. An opportunity for four poses leaves room for experimentation: a small piece of private theatre, with none of the inhibitions prompted by an audience. And if you don't like what you get the cost is small enough for you to throw it away and forget about it – that is until Dick Jewell comes along, scanning the floor around the booth, probing the corners and the rubbish bin, checking the roof, discovers the photograph and puts you in his book.

In the photographic world while portraiture still clings to traditions of singularity, technical quality, character enhancement, distinctive interpretation by the photographer and seriousness, Dick Jewell's book violates all these notions, but it is undoubtedly a book of portraits. It is also found-art, anthropology, an invasion of privacy and a cherished personal collection (like football cards or postage stamps).

It is ironic that probably the first book of photographs both of the people and by the people shows them in a way they do not want to be seen.

DICK JEWELL 1977

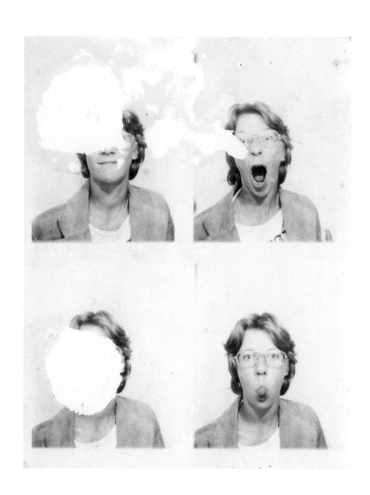

As a picture, this is a landscape; as sculpture it is 'land art' or an 'earthwork'; as a commodity it is a record album cover for The Nice. The back cover continued the photograph to the left, so that the entire sleeve opened up as a panorama.

In this half, sixty plastic footballs proceed single file across the dunes of the Sahara. Why?

'The inspiration came from the music, late at night, and was a simple, spontaneous occurrence. The record evoked images of sparse landscapes. I imagined a desert but it felt too empty by itself and so was soon peppered with red balls, stretching as far as the eye could see, as if they covered the desert from end to end.'[1]

The balls have been placed with scarcely a trace of how they got there. This was managed by locating most of them along the craters' rims or on downward slopes so that footprints might be covered by collapsing sand, and by sporadic application of a brush. But as it's late in the only day available, there has not been time to clean up one flaw, deep in the picture, near the end of the line, marking the place where one of the two photographers was carried away by a Giant Auk. Not far from that spot there is a missing ball.

HIPGNOSIS 1971

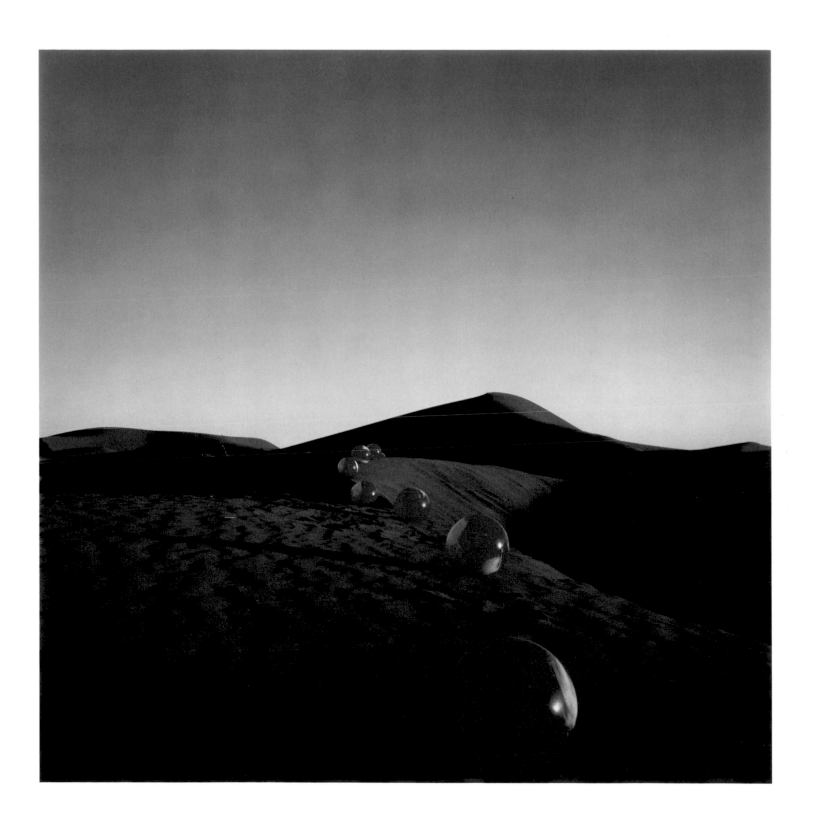

OH DEIRDRE, THAT NASTY BALL!

Deirdre (der' dre), n. Name of the heroine of the great love story of the Ulster cycle; a woman of astonishing beauty, who killed herself to avoid falling into the hands of King Conor, by smashing her head against a rock.

nasty (nah-), a. Disgustingly foul, nauseous; filthy; obscene; disagreeable to smell or taste; annoying, hard to deal with or get rid of; threatening; illnatured, spiteful; awkward; serious.

ball[1] (bawl), n. Anything spherical or nearly so; the orb of sovereignty; any of the heavenly bodies (with distinctive adj.); a globular body to play with; any rounded, protuberant part of the body; a solid missile thrown from an engine of war; a bolus for a horse.

ball[2] (bawl), n. An assembly for dancing.

RON BURTON 1970

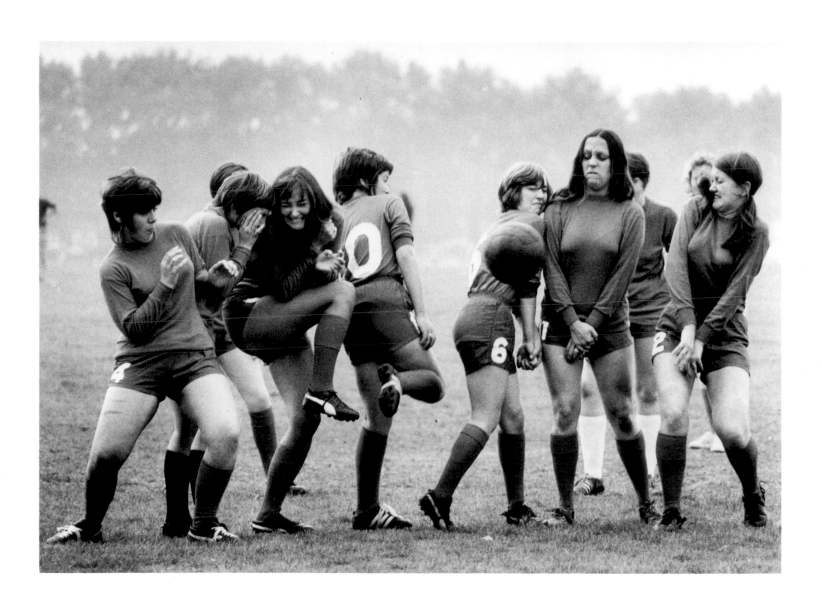

DERBY DAY, EPSOM

Once an anthropologist made a photograph of a Solomon Islander wearing an alarm clock in the extended lobe of his ear. The picture was deposited (along with the clock) in the museum of a university anthropology department in Newcastle-upon-Tyne where it remained until the late 1960s when it was selected to become the catalogue cover of a major, international exhibition, 'Transform the World! Poetry Must Be Made by All'. It is now a widely recognized image, a native, kindred spirit of Dada and Surrealism.

Photography itself is an inherently surreal medium, fixing the visible world in a bizarrely flattened and frozen distortion of itself. It often collects into its many frames the oddest assortment of unrelated junk which instantly becomes related. In snapshots and other so-called naïve pictures this happens repeatedly; photographers often attempt it intentionally. It is a hallmark of contemporary photographic seeing.

For Tony Ray-Jones photography was a contemporary folk dance, whose choreography grew naturally from a people themselves – in this case the English – and whose mystery accrues as the dance proceeds. He once, magically, made an entire beach full of people appear to be bowing on cue. At other times, as in this picture, he confined himself to a tighter space and a greater diversity of performers, working with them attentively, like bits of a puzzle.

His work reveals a fine documentary skill, keen humour and a sincere regard for people, who inhabit virtually all his photographs.

TONY RAY-JONES 1968

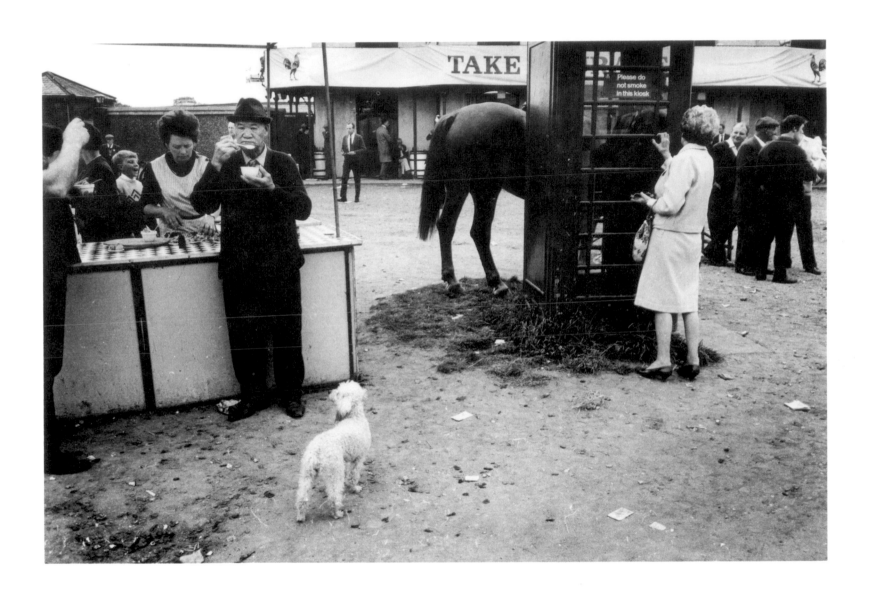

AZELLA IN THE CRYPT

A 'dosser' is someone who is homeless and unable to live in society in an approved manner. The term is entirely pejorative, conjuring up associations of rags, begging, incoherent abuse, methylated spirits, piss and vomit.

The way we consider these people has to do with our awareness of the more desperate seen sleeping in doorways or hanging around stations and parks. This view is reinforced by the way they are often represented in photographs where as a group they have been easily exploited as stereotypes. A homeless person, a weathered face and filthy rags lying in the street, can make for a sensational, effective 'good' photograph, with lots of human interest – but not necessarily much human involvement from the photographer.

Azella was a dosser. For several years she had lived in a car-park under a block of flats in London's East End. It was not too far from the Crypt, a temporary shelter where the homeless and destitute can go for a few hours of warmth, food and company before having to move on somewhere else for the night. A regular visitor, she was killed by a truck just before Christmas 1977.

David Hoffman is also a visitor to the Crypt. In the past few years he has been photographing and interviewing the people there, recording in detail these small fragments of time from their lives. He knows them and they know him. The photograph comes from that familiarity, permitting a tender portrait of someone personally appreciated instead of the stark rendition of just another type.

DAVID HOFFMAN 1977

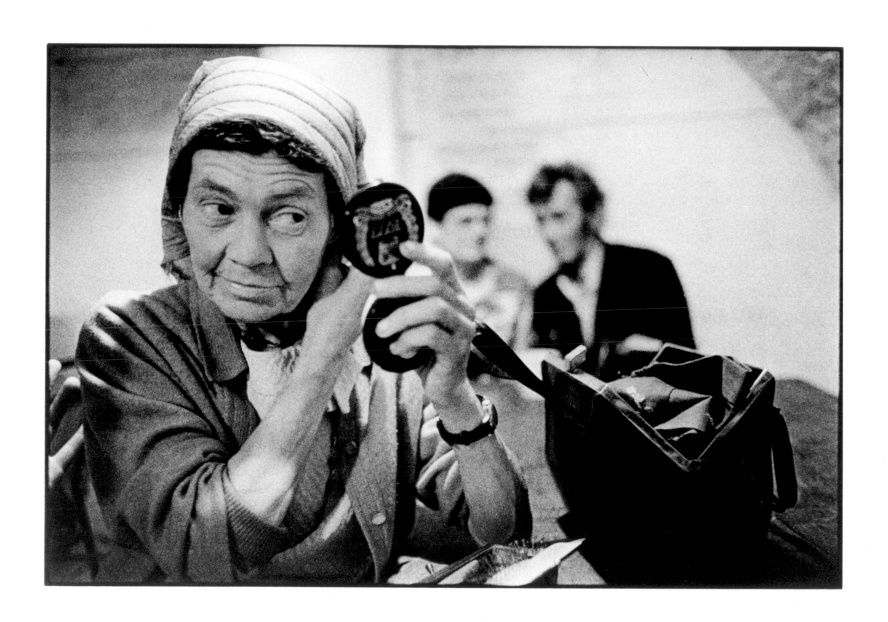

BLOSSOM AND FAMILY

There is a long-serving ethic in 35mm photography of the photographer as the unseen witness who observes but does not interact with events in front of the camera, appropriating pictures from life as they appear. This approach may require an awareness of the interactions within a situation but rarely direct contact with the people who comprise it.

Some photographers do not like to work this way but still seek the natural spontaneity that flows from the seized instant. For them photography must be a collaboration. Whatever may have been lost through exposing their role and intentions is compensated for by the increased access and involvement in the lives of the people they photograph, and the knowledge that their recorded moments are given rather than taken.

The picture opposite was made by a photographer sensitive to the mood and telling details of his subject: a mother and the family relationships that revolve around her. The family is at home watching television late in the evening before the kids go to bed. The photographer shares the room with them and even momentarily fills it with his bounce flash; yet there is no sense of intrusion.

NICHOLAS BATTYE 1977

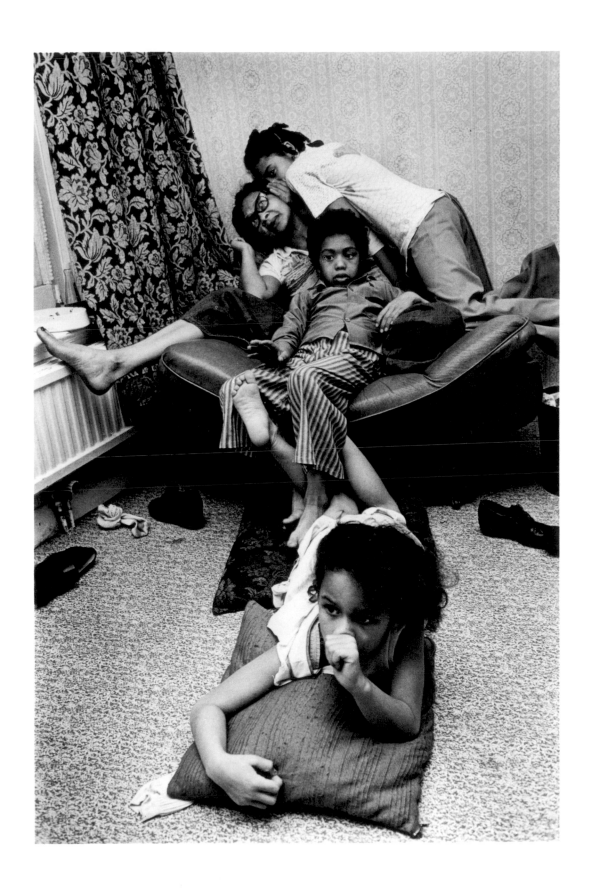

Probably the best known of photography's aesthetics which is photography's own creation rather than a collection of various attitudes and tendencies inherited from painting is that of the 'decisive moment'. The term is most closely identified with the work and words of the legendary French photographer Henri Cartier-Bresson.

Cartier-Bresson's way of seeing is characterized by a skilful blend of formal clarity and careful timing, with a concentration on ordinary people and ordinary situations. His concept of decisive moment is also his definition of the medium:

'To me, photography is the simultaneous recognition, in a fraction of a second, of the significance of an event as well as of a precise organisation of forms which give that event its proper expression.'[1]

Importantly, this statement presents both formal and functional concerns as subject to an awareness of meaning and its conveyance. The decisive moment is not merely an external affair, a dramatic instant seized from a rapidly changing world, but something which takes place on the photographer's side of the camera, as a personal moment of 'recognition', triggering his response.

Decisive moments are not confined to a certain style or genre of photograph but occur throughout the medium and are integral to it. They can require the briefest, ten-thousandth of a second flash or the better part of a day. They might involve the assassination of an enemy or the passage of light across a valley. They will be different for each photographer. Selecting a moment and framing it is the individual photographer's role; the camera preserves it.

Additionally, chance plays its part in any selection of a decisive moment. To some extent in making pictures one is always shooting ahead of the target in time/space, in the hope that the photograph will become what it seems to be becoming by the time impulses from the brain translate into the shutter's release. A situation can develop, like a storm gathering on a clear day, and the photographer has to be able to smell the moisture in the air and feel the change in pressure to know or sense what may happen. Cartier-Bresson's contact sheets reveal that he often makes twenty or more exposures of the same situation, working it and waiting for it to become *his* image of itself. It is part of his responsive process, transforming 'accident' into intention, by means of recognition. Similar occurences of recognition are familiar to all artists. The painter Francis Bacon relates: 'In my case all painting – and the older I get, the more it becomes so – is an accident. I foresee it and yet I hardly ever carry it out as I forsee it. It transforms itself by the actual paint. I don't in fact know very often what the paint will do, and it does many things which are very much better than I could make it do. Perhaps one could say that it's not an accident, because it becomes a selective process what part of the accident one chooses to preserve.'[2]

Or, perhaps of more direct comfort to photographers' egos, there is the story of someone confronting Edward Steichen at a photo-exhibition, 'If you were to take out of this show all the "accidents," how many would you have left?' 'Not many, perhaps', Steichen replied, 'but have you ever noticed how many great accidents have been made by great photographers.'[3]

A myriad of events transpire to make Ken Baird's picture. The forest setting and costume of the hunt are perfect for the theatre they become. Each event occupies the moment from a different segment of time – from the relatively gradual positioning of horse and hounds, to the magical touch on the boy's shoulder and his reaction, to the seemingly disconnected, silhouetted presence of the walker passing on the ridge behind.

KEN BAIRD 1974

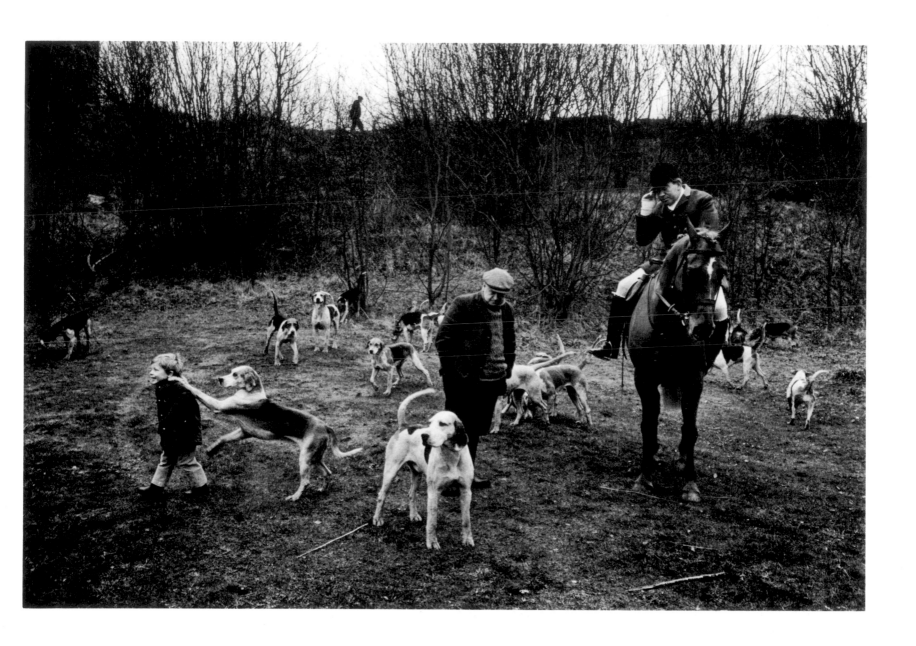

Within its unusually widened format, the panorama camera presents special problems of organizing the picture. Originally designed for landscapes and group portraits, it is more often used these days to produce gimmicky illusions and exaggerated effects. Paul Joyce employs the camera in older ways, with considered authority.

He presents an attractive and dramatically approachable picture. It can be read from the left or right or straight into the middle, traversed by high road or low, circumambulated through the hills beyond the lake or by following the sun towards the rainbow's end. And, upon returning home, it provides a comfortable space in which to settle. What more can you ask?

PAUL JOYCE 1976

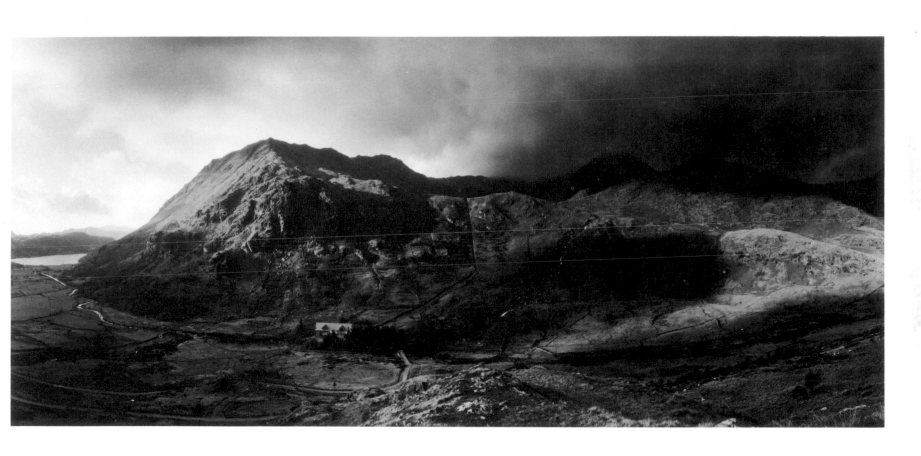

CATHY MORRISEY AND FAMILY

How much do we know about people merely from watching the way they sit, stand or move? Can we tell if they are happy, ambitious, intelligent, artistic, honest or sane? How much less are we accustomed to learning from their photographs?

You don't need the title to see that this is a family. Their feelings for one another are reflected in the comfort and openness of their touching – an intricate, human bonding both gentle and strong – as they share a blanket under a tree in a friend's back garden. They have come to London from a cottage in the Welsh countryside; life there was hard and they hope to find work and a new place to live in the city. Some of this is visible, in their clothing, in a slight uncertainty detectable in their faces and in the vulnerability and anomaly of their situation in the photograph.

Portraits are made for all sorts of reasons: simply for identification, as important records, to confer status, in insult, to lay bare the soul and just for fun. They may picture the notorious and powerful or the anonymous and lost, but in the good ones their subjects are no longer strangers.

The Morriseys did not find what they were seeking in the city and now Cathy and Tony and their daughters Poppy and Tasmin are living again in a cottage in the Welsh countryside. Their dog Bole has died.

BRUCE RAE 1979

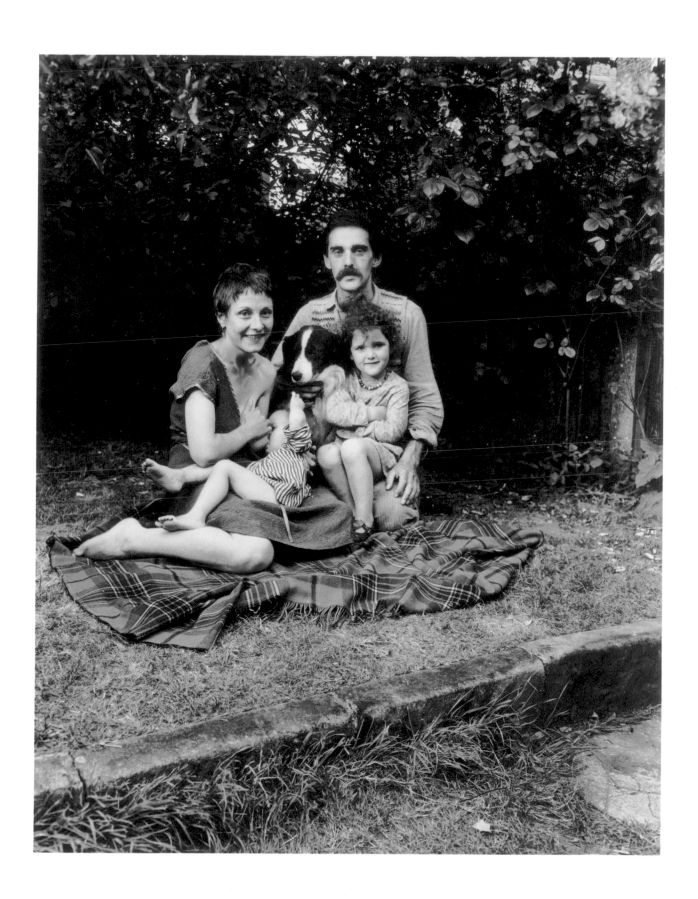

'STORMS CAUSE WIDESPREAD DAMAGE AND FLOODING IN THE SOUTH'

'Thunderstorms over the southern half of Britain early yesterday damaged homes, flooded roads, disrupted rail services, battered crops and made a dismal backdrop to the start of Royal Ascot . . .

A woman drowned when her car plunged into the swollen River Ouse at Bedford last night. Police divers recovered her body . . .

At Ascot course officials estimated that one and a half inches of rain had fallen in 36 hours. But the racing was on . . .

As the royal party drove along the course the wheels of their open landaus sank into the wet ground . . .

Officials ruled that Mrs Gertrude Shilling's Jubilee Year offering, a 3ft high by 6ft wide red, white and blue hat, was not suitable for the comfort and viewing of other race-goers. Mrs Shilling changed into a silver fox fur hat and coat and was then allowed into the Royal Enclosure . . .

In Ipswich a sausage factory on the outskirts of town which caught fire at the height of the storm is thought to have been struck by lightening . . .

A stack of paper pulp in Snodland near Rochester was struck by lightning and badly damaged by fire . . .'

From *The Times*, London, 15 June 1977

ANDY EARL 1977

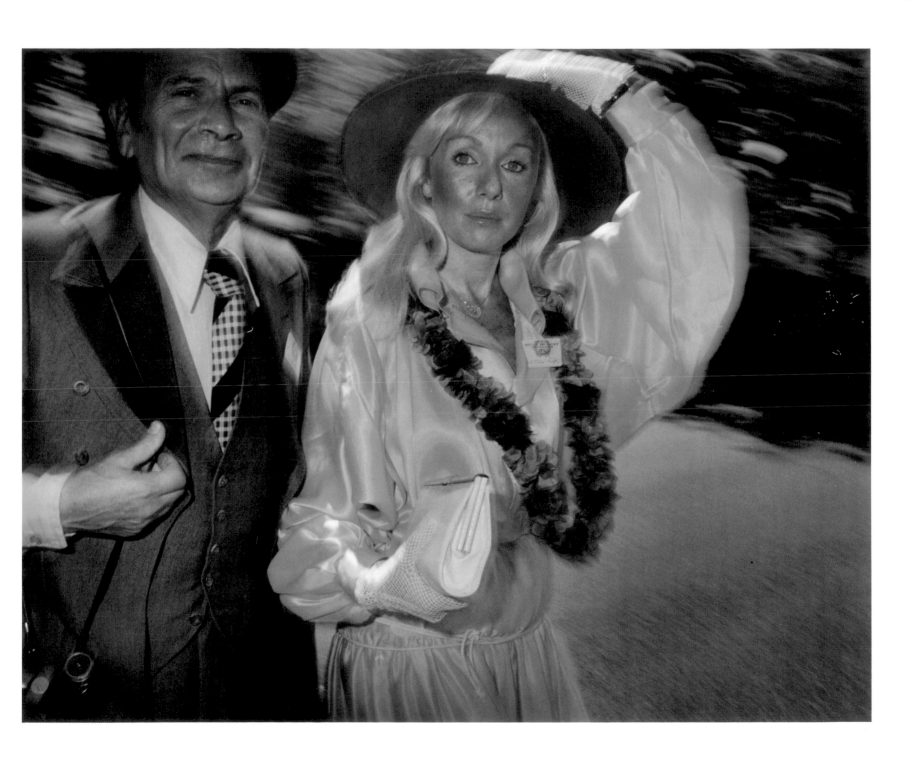

THE BLACK HOUSE

There is no urgency here. It is ten past five in the Black House, a hostel for black youths who have been in some kind of trouble. Those who stay here come from court, prison, or have had a row with their parents. Some stay only a night or two; others keep coming back.

For many people hostel life is the start of a long slide into decline, loss of dignity, self-respect and meaning, if it isn't already the end of that trail. It can also be the first firm foot-hold in a shifting world. It is the intention of the Black House to provide stability and support in order to break the spiral of crime and imprisonment that leads from minor charges to hardened criminals. For many black youths their first encounter with the law is a charge of 'Suss', an application of the 1824 Vagrancy Act which allows the police to arrest someone merely on suspicion that they are likely to commit a crime. Such a law is readily abused and, in our prejudiced society, most frequently directed against blacks – in 1977, they made up 44% of all 'Suss' charges in London.

There is no information on the background of these two youths, but they appear not to have lost their self-respect. Their response to being photographed is neither hostile nor servile. They are quite smartly dressed and relaxed, sitting on a bare mattress in a bare room, facing a future that for sure holds no velvet lining. They look neither at each other or at us. This time is their time – time to just sit back in warming sunlight and ease into the sweet smoke and savour of an afternoon joint.

COLIN JONES 1978

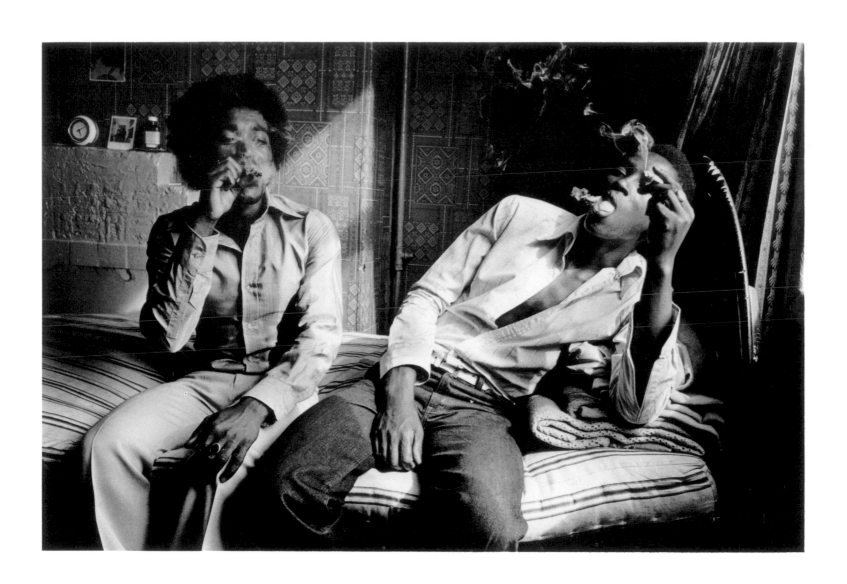

It is incredible how far some people will go for a picture – even if only for a fuller picture of their world from the highest possible ground. No landscape painter ever sought a loftier overlook or broader vista. No 'land-artist' ever documented the turning-point of a more arduous walk. No tableau photographer ever utilised so small a stage set against so immense a backdrop.

From its early days, the camera has accompanied exploration, whether up the Nile, over the Rockies, under oceans, into the womb or out of our galaxy. Photographs corroborate and collaborate with experience, providing both a reason and means for participating in it. Many expeditions, investigations and experiments would never be attempted unless they could be photographed – photographs increase their value, extend and even create their information. In some instances (as with aerial reconnaissance, bubble-chamber photographs, time-lapse, infra-red and x-ray records) photographing provides the sole meaning of an undertaking. Even when this has not been the case it may well be that the photographic image outlives even personally remembered experience and most effectively determines our historical impressions and awareness.

The man photographed on the mountain's top is Dougal Haston. He and Doug Scott were the first climbers to scale Everest's 29,028 feet by its most difficult route, the South West Face. The time was 6 pm, 24 September 1975. In his diary Haston wrote: 'We were sampling a unique moment of our lives . . . Down and over the brown plains of Tibet a purple shadow of Everest was projected for something like 200 miles. On the North and East sides there was a sense of wildness and remoteness . . .'

Scott wrote: 'All the world lay before us . . . my usually reticent partner became expansive; his face broke into a broad smile and we stood there hugging each other and thumping each other's backs'.

How does one sum up so remarkable an experience; the courage, stamina, individual will and group effort that makes such an event possible? What must it be like trying to photograph the climactic moment? Doug Scott recounts:

' "Here you are, youth; take a snap for my mother." I passed him my camera. "Better take another one; your glove's in front of the lens." '[1]

The most elevated snapshots on Earth.

DOUG SCOTT 1975

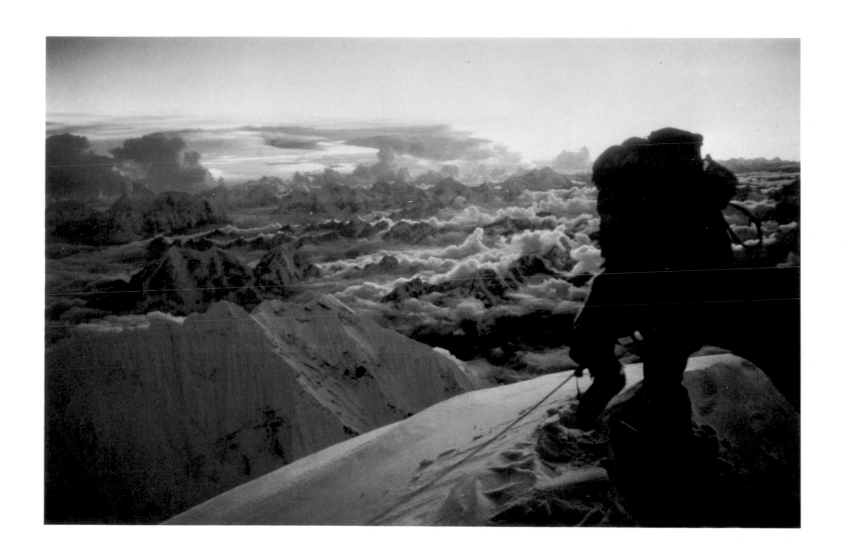

STANDING STONE, PRENTEG ROAD

Fay Godwin has been labelled by many as a contemporary English Romantic, but this is not to say her work is fanciful or vague, a dreamy retreat from reality, irrelevant, unnecessary or whatever else may be the modern, pejorative connotations of the word 'romantic.'

Her photographs portray a natural landscape of light, texture, atmosphere and space, qualities which she employs to evoke more fully a sense of place. The work acts to preserve this environmental heritage from an encroaching, mechanistic future. Relishing efforts to surpass the medium's limitations, technically as well as aesthetically, she seeks to make pictures whose elegance is drawn from both the drama and the simplicity of their seeing – pictures of wonder.

She found this small, cracked rock along one of the old drovers' roads in Wales. It is a Standing Stone – rather than a marker stone and like the ancient monuments of Stonehenge and Avebury it holds secret meanings at which we can only guess.

FAY GODWIN, 1976

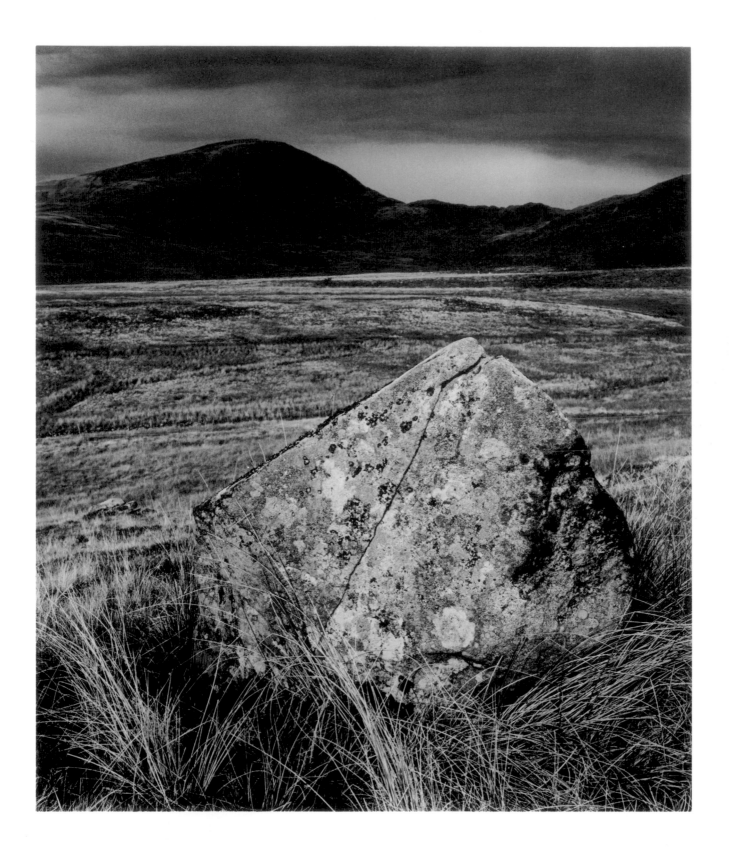

ST. MICHAEL'S MOUNT, CORNWALL

At one time a large forest covered the coast around St. Michael's Mount, hence the ancient Cornish name for it is 'Carreg luz en kuz', meaning 'The white rock in the wood'. It was known to be a high place of Druidical worship.

Before Christianity reached these shores there were many legends of giants connected with the Mount; one of these supposedly explains how it came into existence.

It is said that the Giant Cormoran wished to build his home here and to raise it above the trees so that he could keep watch over his rivals in the neighbouring countryside. He selected the white granite rocks from the surrounding hills and with the help of his wife, Cornellian, carried them back to the site. She tired of searching further and further afield for the white rock her husband preferred and so began to collect instead the nearby greenstones, carrying them in her apron. When Cormoran discovered this he followed her and, in his anger, gave her a great kick. The apron strings broke and a stone fell into the sand. No human power has been able to move it from where it landed.

The photographer does not know if this is that stone or not.

SIMON MARSDEN 1976

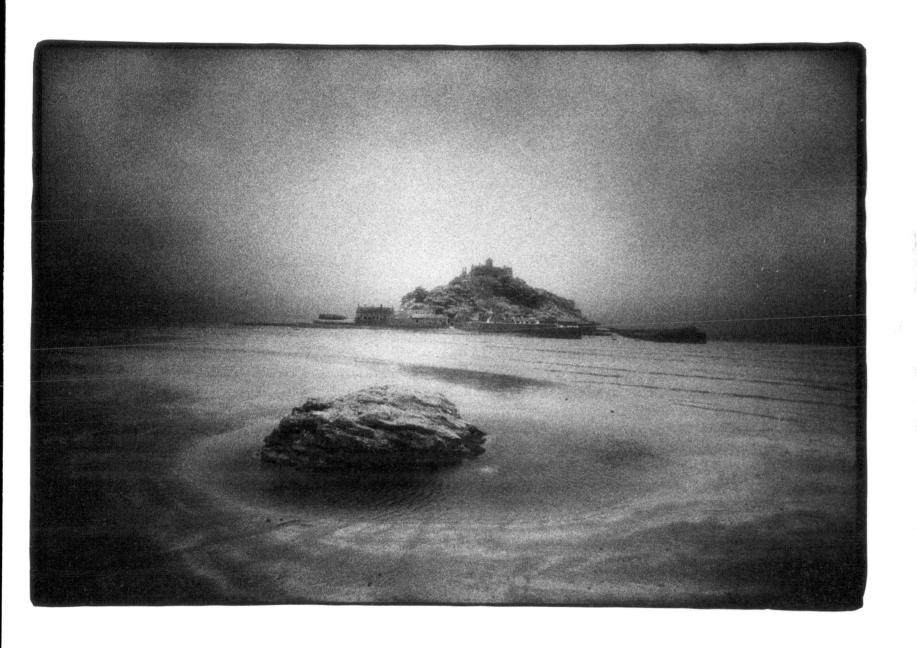

CHRISTIANIA

Photographs sometimes seem remarkably insubstantial when compared to the tasks they are asked to perform. Tiny, rarified and distilled images deposited on to comparatively fragile pieces of paper or plastic have been held responsible for our image of the world.

Mark Edwards spent two years in Christiania, a squatting 'free colony' on the outskirts of Copenhagen, and has published a book on the place. He began the project as a reportage photographer, but had to become a commentator and interviewer as well, realising that photographs alone were insufficient as a means of presenting the community in its entirety. The writing provides a history, biographies, reminiscences, analyses, fills in photographic blanks and speculates on Christiania's future; while the photographs describe the community, record its events, portray its people, serve to illustrate and expand the text and act as evidence. The book contains more than 400 photographs. Edwards points out that this represents no more than four seconds of real time into which two years must be compressed.

If 400 photographs are inadequate for a full documentation, how much more so is one? But being inadequate to this task, one can still be more than adequate as a singular record to be looked at and responded to. What can not be fully revealed can sometimes be implied, and the photograph may be as potent through what it excludes as for what is contained.

A strange, medieval ceremony is in progress, a mythical pageant set against a backdrop of low-slung bungalows and contemporary sameness. One individual, an apparently ordinary person, sits indifferent to its passage. This is one of Christiania's many processions which have become its major art form.

The photograph represents two realities distinct from itself: the external world and the intuitive responses, emotions and understandings of the photographer must both come together in a significant and convincing manner – the fullness of an individual's experience expressed in a handful of tonal fragments. It is an impossible task; yet, as with mining silver, or writing poetry, people continue to engage in the process of creating photographs in the belief that the concentrated result can be of disproportionate value to its means.

A good reportage photograph is expected to record and transmit information accurately, but this need not be a static, closed event. If the two realities of the 'objective' and 'subjective' world come together effectively, what is seen does not just mentally register, but reverberates in our imagination and memory.

MARK EDWARDS 1977

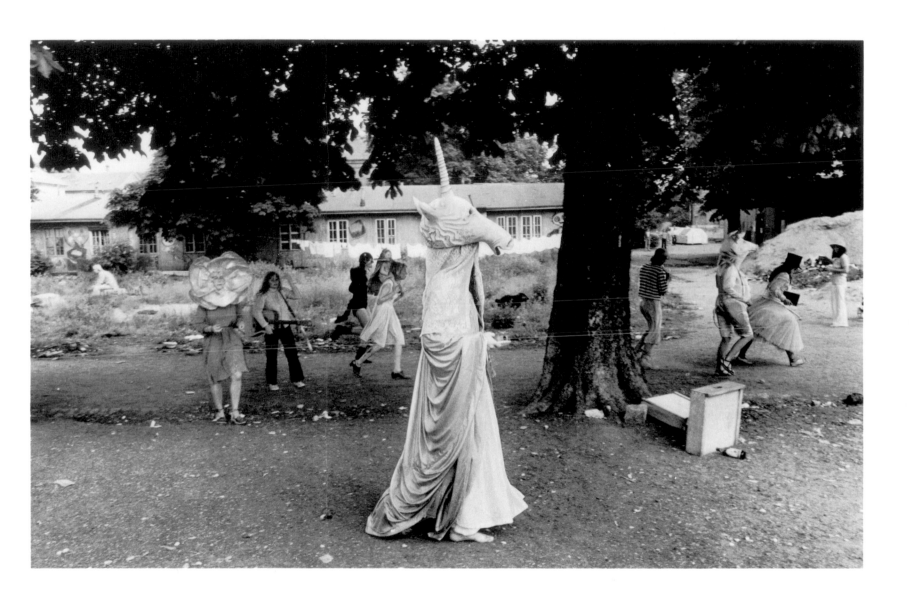

So, what d'ya make of this?
Very 'English,' I'd say.
Tripping!

Do you think he's off the ground?
It
What?
'it's'
. . . Just.

One thing that interests my head is how that acts as a shadow.

Miles from Heartfield.
And Ernst?
'Ariel.'
What?
Shakespeare . . . biological, like Tide.
Tide's not biological.

It's not very deep.
Doesn't have to be
Yeah, well . . .

Did you do that?
What?
Open your sandwiches?
Eh?
Crack an egg?
I don't know what you're talking about.
No? . . . must be the fridge.

ANDREW LANYON 1966

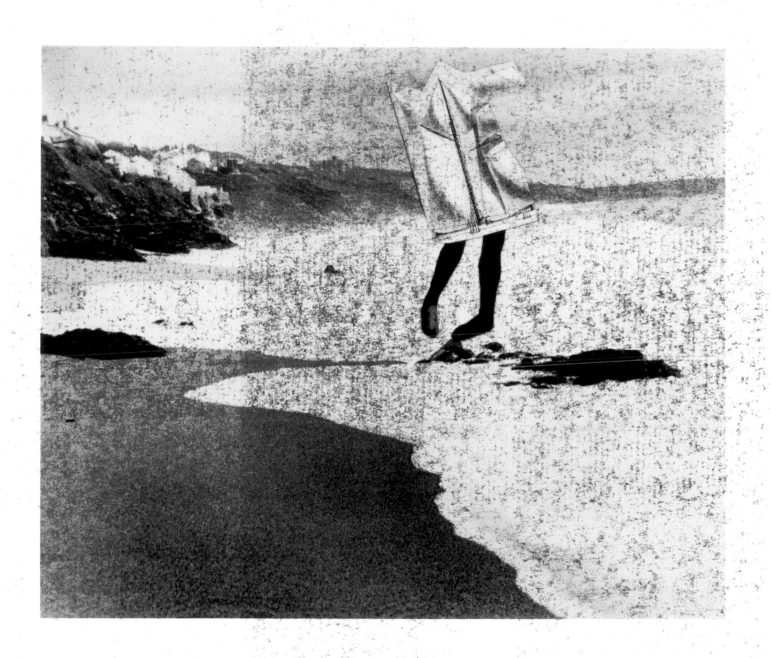

62 CAUSE OF DEATH

This picture demonstrates how framing affects the way a photograph is read and how captioning spells out its meaning – offering elegant forensic evidence that, although the camera cannot lie, photographs tell different truths.

JOHN HILLIARD 1974

CRUSHED

DROWNED

BURNED

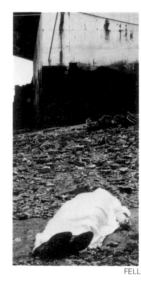

FELL

Photographs are readily seen as being about the subject matter photographed and the power of their peculiar representational system is so strong that – inevitably – they are, whatever else they might be.

The system operates through a range of formal conventions, some inherited and some unique, including linear and aerial perspective, tonal gradation and density (highlight and shadow), variable focus, exact proportional relationships and a wealth of informational detail. They help create a formal language for photography with more persuasive capability than that of previous picture-making systems. Re-arranging or re-emphasising these conventions can suggest or even force alternative understandings from ordinary objects and events. Such manipulations occur throughout the medium and have been regarded as anything from eloquence to lying.

One way to understand this process is in terms of form and content. New information is produced in photographs either through the recording of new subject matter or the utilization of new formal structure. Each, acting upon the other, results in new meaning and can be perceived as creative. Most public photographs function in the first way, relying on relatively standardised forms to promote their various 'new' products, personalities, places, events, etc. While the history of 'art photography' has been based upon a search for innovative form in which to present traditional subjects – greater artistic recognition being conferred more often upon new ways of seeing than on new things seen.

Paul Hill's picture does not present sensationally new subject matter: in fact, it is all quite familiar – legs, rock, road, houses, trees. But the way in which these elements are combined is not so familiar. The scale, framing and vertiginous view-point are confusing, their intended meanings deliberately ambiguous. The legs, amputated from their identifying owner, seem to be a young girl's, her strapped on shoes protruding beyond the large, arm-chair like rock. Below them the road twists through a dark valley, past the end of the village; while, just below the road something that looks like the sea laps away at the picture's edge. In an elegant arrangement, the formal relationships of these objects and their roles in the fabrication of meaning are the photograph's *subject*, the objects themselves its *subject matter*. It is only through both that the photograph's real meaning can be found, invented or inferred from the possibilities provided.

PAUL HILL 1975

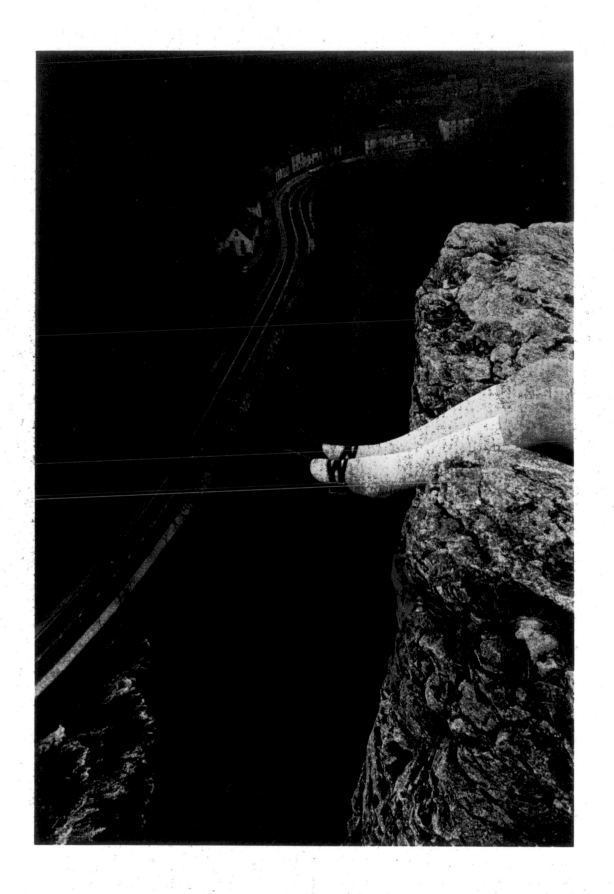

In some East European countries it is customary to observe a moment of silence and stillness before departing on a major journey. It is unlikely that the child here has made or will actually undertake such a journey – except in her imagination as a magical English adventure into which we are invited through the moment of exposure when these possibilities are briefly opened.

BRIAN ALTERIO 1976

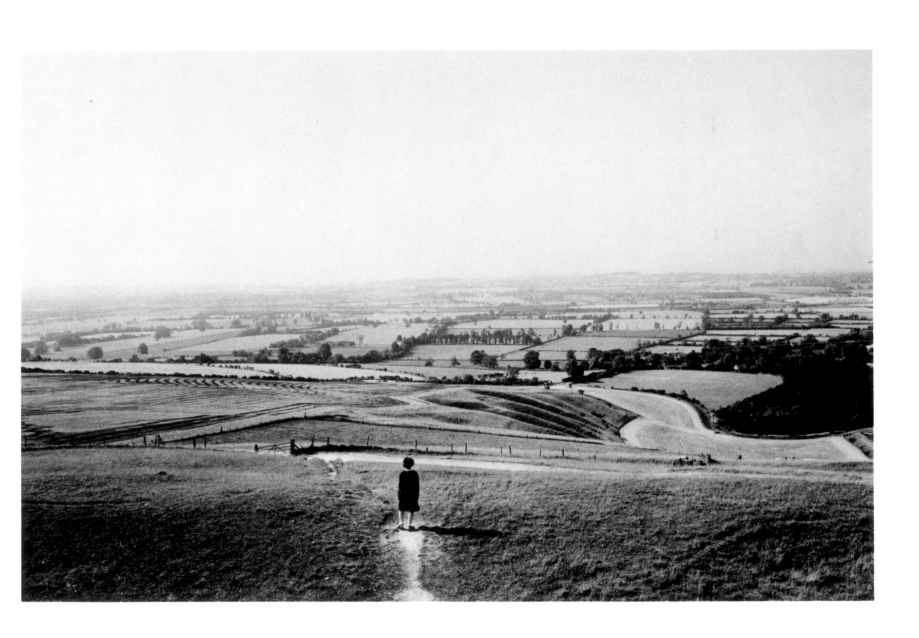

JEAN RHYS

From the early 1930s Bill Brandt's work has spanned the social documentation of London and the North of England and the pervasive class structure, industrial and ancient landscapes, environmental portraits of artists and writers, dramatic and abstract nudes, human and natural detail. The work's diversity has not affected its consistency, displaying Brandt's special mastery of form and space, strong tonal contrasts and an evocative sense of drama and melancholy.

Throughout his remarkable career Bill Brandt has continued to work as a magazine portrait photographer. His vision is still clear and his sensibilities sharp. He uses his special skills here, gently and certainly, in an old man's picture of an old lady.

This portrait of the author Jean Rhys was made for the *New York Times Magazine* when she was living alone in a cottage in Devon.

BILL BRANDT 1975

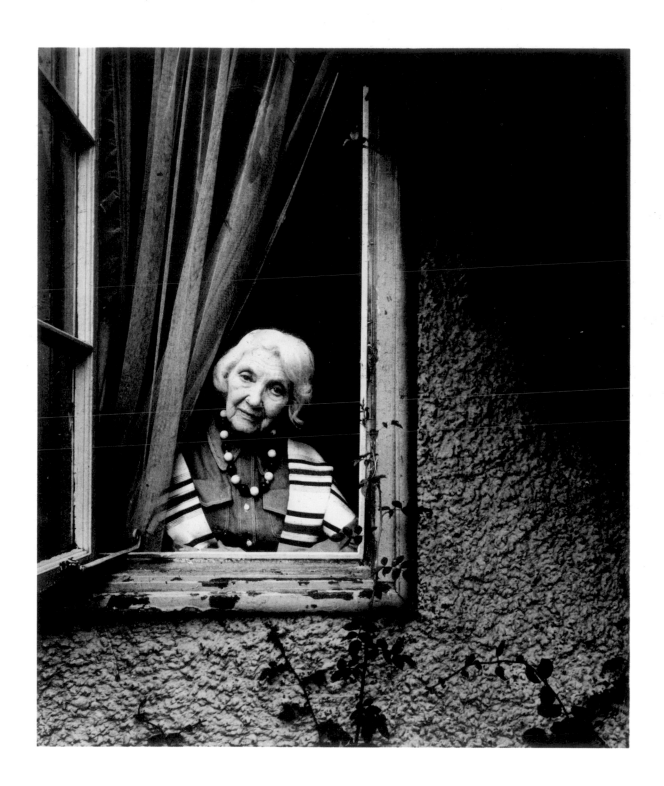

HIGH LEVEL BRIDGE, NEWCASTLE-UPON-TYNE

When Graham Smith offered this and similar photographs of the people of Tyneside to the local library they were rejected on the grounds that they were not documentary in nature – as they were collages – and therefore could not be used for their information. This attitude reflects both the prejudice against what is seen as 'making' rather than 'taking' a photograph, as well as a pervasive, blind acceptance of the 'truth' of straight photography.

This image is as valid a document as many other photographs and more so than most in its concern for the feeling of the area: its people, physical environment and light. It records and describes these clearly and accurately. The changes which do occur (in lighting and scale) are minimal compared to distortions which are acceptable and commonplace in 'straight' photography due to the use of telephoto and wide-angle lenses, flash and other artificial lighting, and the common practice of re-enacting recordable events for the camera. Both the photographer's intent and result place his picture firmly within the documentary traditions of the medium.

GRAHAM SMITH 1973

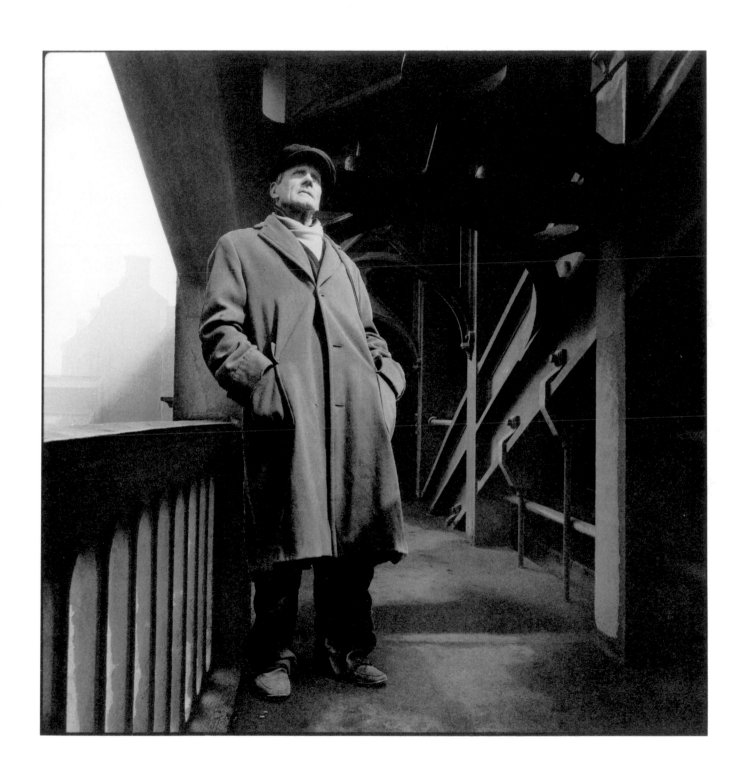

EMMA'S WEDDING

Maybe we should begin by introducing everyone. Emma, obviously, you will recognize. The bunny-topped bridesmaid is her sister; so is the woman with the spectacles next to her, and the person with her hat in her hand, and the cold one with the bun on her head. On the far left, with the pink carnation, is a sister-in-law. The small boy is cuddling up under his aunt's elbow; his mother is next to her, with the spectacles.

Emma's husband's mother's mother, her grandmother-in-law, is actually left over from a previous photograph. Having positioned herself and removed her glasses for the picture-taking she was not particularly inclined to move just because a different set of people had gathered behind her for a different picture (one of 'the girls' together).

David Butterworth came to the wedding because he was invited, knowing Emma from his neighbourhood pub. His portraits – often the identical twins of snapshots – are made deliberately and knowledgeably, aware of the history of the medium and familiar with the ideas of many of its practitioners. Yet he has selected a 'style' more often associated with naïve photography and persists in this manner unbothered by the successes and failures of current fashions. It seems likely he does this for many of the same reasons as the family snapper, among which are an interest in and caring for the people photographed, and an inclination to make pictures as straightforwardly as possible.

DAVID BUTTERWORTH 1976

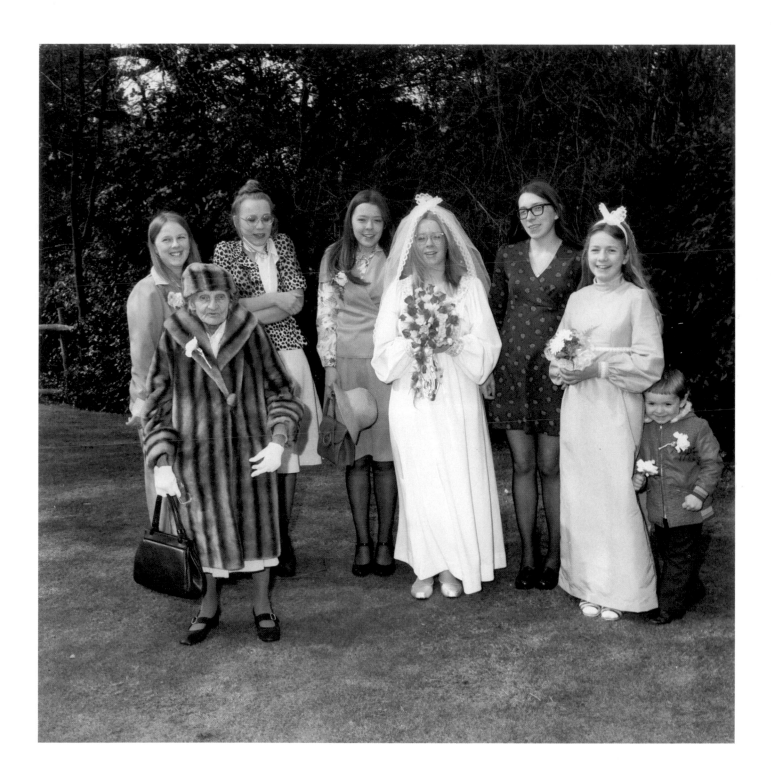

Traditionally communities have been photographed by outsiders moving in on an area, be it a Spanish village or a London slum, working there for a while and moving on, taking their photographs with them to show the rest of the world.

The Community Photography movement, which has developed so rapidly over the last few years in Britain, may be broadly characterized as an attempt to use photography within and for the benefit of the community. Motives vary widely, from wanting to encourage people to photograph friends, family and their environment as this '. . . provides immediate feedback for discussion . . . aids storytelling and reading, and makes it possible to look at the world differently; people can discover how to relate to themselves and each other more positively. . . .',[1] to a wish 'to turn the *objects* of conventional social documentary photography into agitators for change'.[2] Community photography can also be seen as a service, providing people with access to the medium, much as they have access to libraries, laundrettes and sports facilities. The differences in approach are many.

Ultimately the label of Community Photography is misleading, as it suggests a unity of thought and action and a concept of community which do not actually exist. Its emergence was essential, however, to focus attention on the need to make photography available to people who usually do not have such opportunity.

The socially orientated magazine *Camerawork* features this photograph on the cover of an issue subtitled 'Photography in the Community.' It was more or less taken by one of a group of children aged between 7 and 16 during an intensive one-day session organized by a community arts team. Those who opted for photography went off with cameras in the morning, developed the film at lunch-time and made or received their prints in the afternoon – a somewhat hectic affair which was repeated elsewhere with other unsuspecting kids on different days. Whatever the long-term benefits of such activity may be for the community, clearly (even though a camera might go wrong) this family derived at least one photograph and a great deal of enjoyment from the process, and both results have much to recommend them.

VICKY LACK 1978

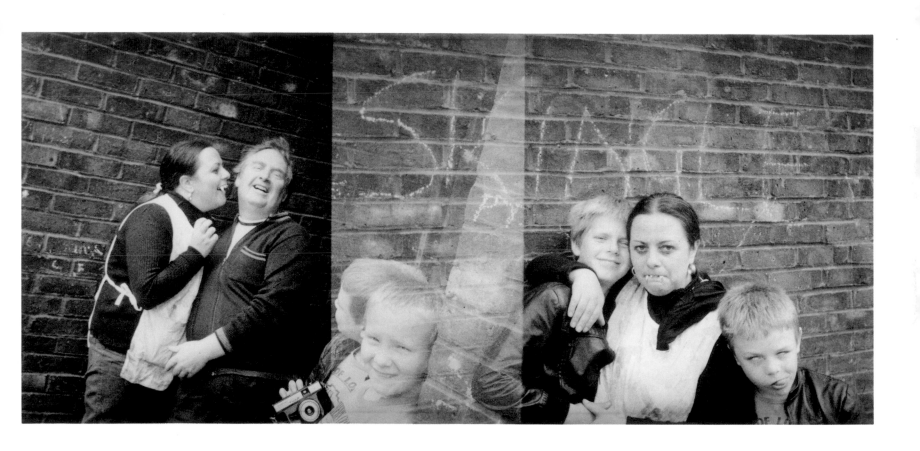

This picture was made for an orthodontist as part of a five-year research project to enable accurate serial measurement of children's facial growth. It has been extracted from a record of twenty-five pairs of twins of like sex photographed at yearly intervals (hence, '4-Dimensional Measurement'). Twins were chosen to provide comparative studies between children born at the same time to the same parents and brought up in the same environment. The information derived from these studies is used to decide the most appropriate periods to apply orthodontic treatment.

The top pairs of photographs of the girls' faces were made by a specialized stereoscopic camera. When combined, each provide information of depth (in the way binocular vision provides us with depth perception) to be decoded by a computer into two-dimensional, two millimeter interval contour maps – as precise and distinct as fingerprints. Then, in the same way as architects build up site models from their plans, these maps were translated into three-dimensional models by form-cutting sets of two millimeter thick sheets of high density polyurethane to the same outlines as the contour plots and stacking the forms sequentially. These models were then photographed and combined with the previous recordings to produce the finished photographic document seen here.

Although it is a complex image, involving a multiplicity of visual and technical processes placed within a rigorous comparative framework, the photograph's formal concerns are non-aesthetic. It was produced solely in pursuit of stwait theeth.

L. F. H. BEARD 1976

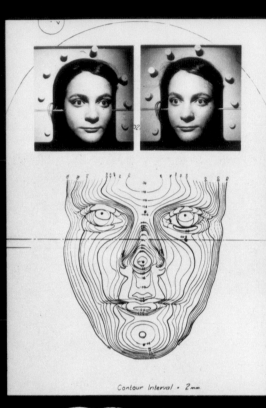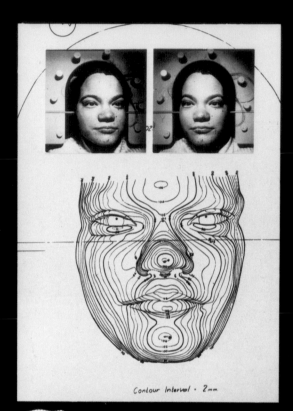

Contour Interval · 2mm. Contour Interval · 2mm.

Many photographers approach the landscape with a concern to embody in a single photograph their unique experience of a place, celebrating *a* moment as *the* moment.

Phillippa Ecobichon is also concerned with place – her identical framing insists that we recognise the same field, photographed from the same position. Side by side, the images echo each other, neither taking precedence. Our attention is drawn towards a cataloguing of the differing detail between the photographs, in consideration of the natural progressions of change. Rather than being a single photographic moment, time itself becomes a formal element and subject of the work.

Ecobichon's photography is a more preconceived than a spontaneous response to the landscape which blends picture and process, each as a vehicle for revealing the other.

PHILLIPPA ECOBICHON 1977

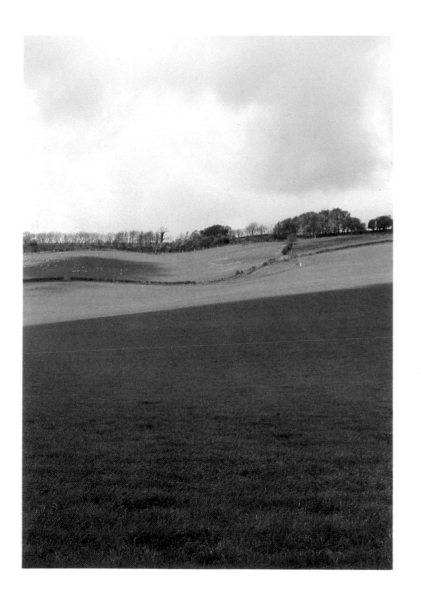
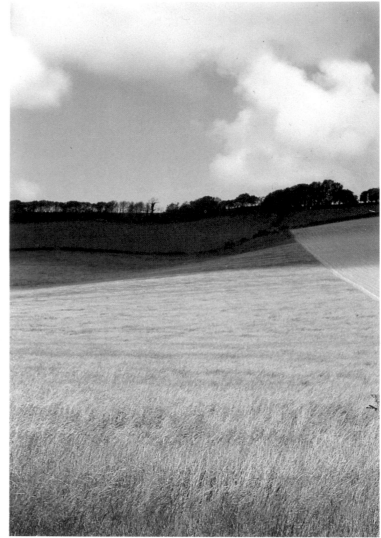

PASSING NATURALISTS

An official outing of the Surrey Bird Club is both an occasion and an adventure, which may result in a full-scale expedition, as has this one to Pagham Harbour in neighbouring Sussex. Besides avid ornithologists such an event is likely to 'pad out' with wives and husbands, even attracting Martin Parr and the odd naturalist.

Here are two serious specimens of the latter category thoroughly enjoying their pursuit of Nature. Both males, they are performing a ritual 'passing' in one of the tall grassy areas they love to trample. Making little attempt at camouflage they are easily identified by their distinctive knitted crown, large ears, sock-ringed rubber feet and the peculiarity of their bearing. The mature naturalist is distinguished by his pipe, walking stick and darker protective covering. Ordinarily gregarious, it is quite inadvisable to disturb this breed during outings as they are entering their most intense and unpredictable phase.

For best photographic results, combine long observation and high sensitivity with short shutter speeds and a touch of eccentricity.

MARTIN PARR 1974

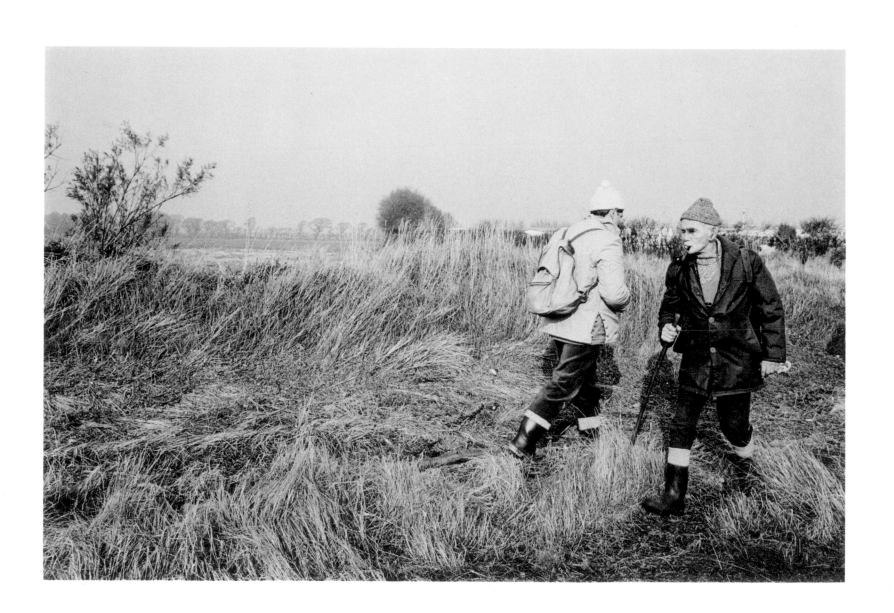

This picture of Helen McQuillan's is an open book. The language in which it is inscribed is one of private symbolism expressed through carefully chosen objects. It refers to the processes of change and decay, familiar and alien forms, notions of beauty and ugliness and the varying identities of actual and apparent, artificial and real in photographic representation. Silver is visible as a rock, shrivelled fruit, crumpled paper, a cake-cup and the effect of light on a page. Red is a rose and similarly a radish. A rotted lemon has acquired a hue to echo and blend with the supporting page. Decomposing vegetables offer letters, words. Organic and inorganic materials restate each other interchangeably.

The photograph appears originally as a 5″ x 4″ transparency in a heavy, secretive, leather-bound book of Helen McQuillan's colour photographs. There it performs through a window on a detachable card set against a white backing between pages of alternating colour and pattern, across which references and allusions feed back and forth from image to image – serving as a unique book within a book. Removed, it can be viewed in different positions against differing backgrounds, its plastic pages again transparent. Reproduced here, it is returned to the fixed page, reflective, complete: an open book in an open book.

HELEN McQUILLAN 1976

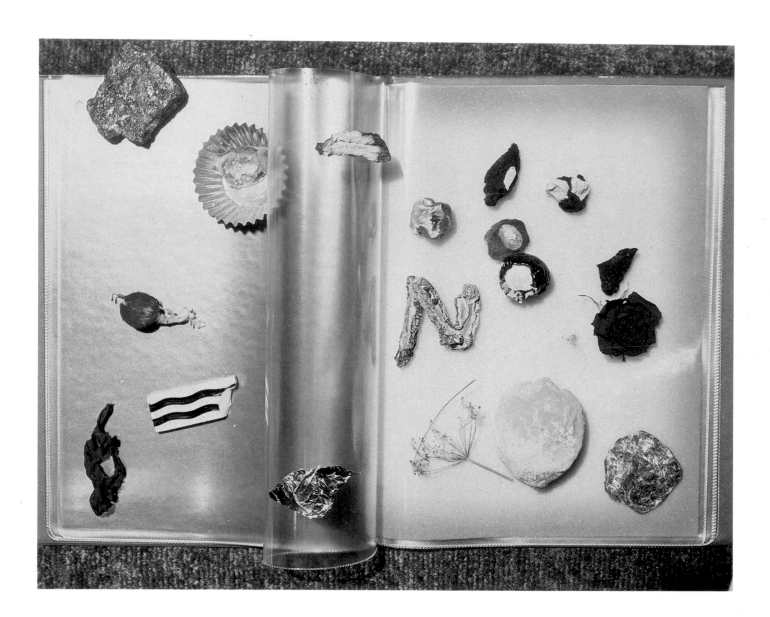

This photograph was taken simply to demonstrate this particular technique.

DEPARTMENT OF MEDICAL ILLUSTRATION, ST BARTHOLOMEW'S HOSPITAL, LONDON

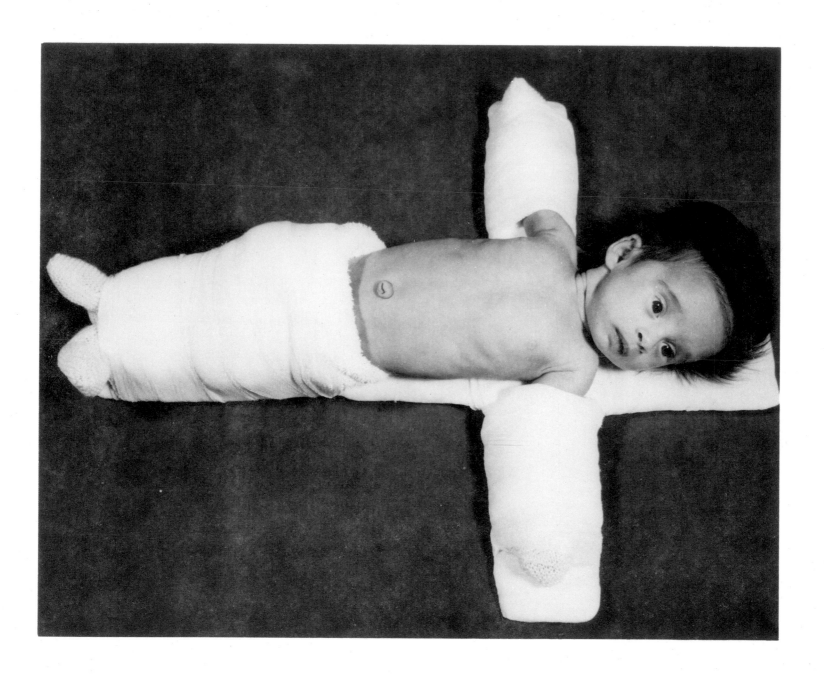

The technique of assembling a photographic still-life has parallels with stage managing a photographic tableau, arranging the elements of a montage, producing a gallery installation or making a photographic book. Objects are chosen and arranged for their private, symbolic or visual meaning.

The Czech photographer Josef Sudek, who died in 1976, frequently constructed elaborate still-lifes, collecting together classical subject matter (fruits, shells, glasses, spheres) in conjunction with more personal items such as letters or gifts and juxtaposing them with eloquent ambiguity. He worked with a large-format camera, often making prints, which are soft by conventional standards, and occasionally leaving any dust marks and blemishes to emphasize that what he was producing was a new object – a photograph – not solely a representational record of his subject matter.

Sharon Kivland's picture ignores all the conventions of 'fine photography.' She employs none of the classical allusions of Sudek (though utilizing items of mixed association and discernibility); her acknowledged influences have been painters rather than photographers. Her fuzzy, emotive, informally framed, Instamatic close-up vision is better suited to a memory than a record. Indistinct, incomplete and nostalgic, yet instantly retrievable, her image is a souvenir, where the Eiffel Tower flows out from its candy-coloured wrap and the Champs Elysées inadvertently heads north to the sound of 'I love Paris' on a penny-whistle.

SHARON KIVLAND 1978

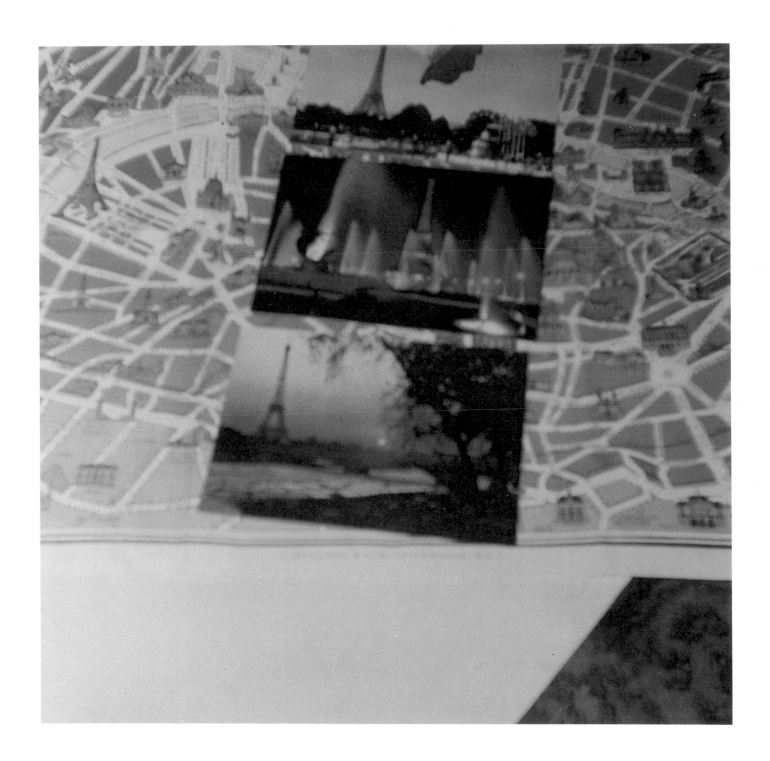

Having spent so much of his life abroad, Ian Berry was in 'the odd situation of being English and knowing very little about England' – so he set about rediscovering his native country as a professional reportage photographer.

The England that Berry rediscovered is a world of grey skies over grey landscapes, ageing urban environments and the ageing institutions of class. This photograph, however, has more to do with a generation than a country.

As a phenomenon that occurred in Britain as well as elsewhere, the open-air pop festival was a symbol of the 1960s 'alternative' youth culture that carried over into the 1970s. It was a movement characterized by anarchistic idealism and personal freedom of expression. Music was its voice, marijuana and L.S.D. its sacraments, and the pop festival its pre-eminent mass ritual.

This is London's Hyde Park. A young man and two women press against the fence at the edge of the crowd. The moment is rich with ambiguity, the photograph charged with speculative and symbolic notions. Two women, two ways of life; the man is between them. One, seemingly more insecure, reaches to him, held in place both by his arm and her own romantic intention; the other moves away independently and must be reclaimed sexually. Her face suggests a kind of pleasure/pain. The man seems emotionally detached, an impassive haloed figure as the archetypal male.

What is actually happening is not known to us. The relationships are unclear and the outcome unavailable. We know only that the event occurred by the fence at the edge of a crowd, in Hyde Park. But instead of Ian Berry merely showing us another fact about England which we already knew – that pop festivals took place – he has looked carefully, revealing more.

IAN BERRY 1978

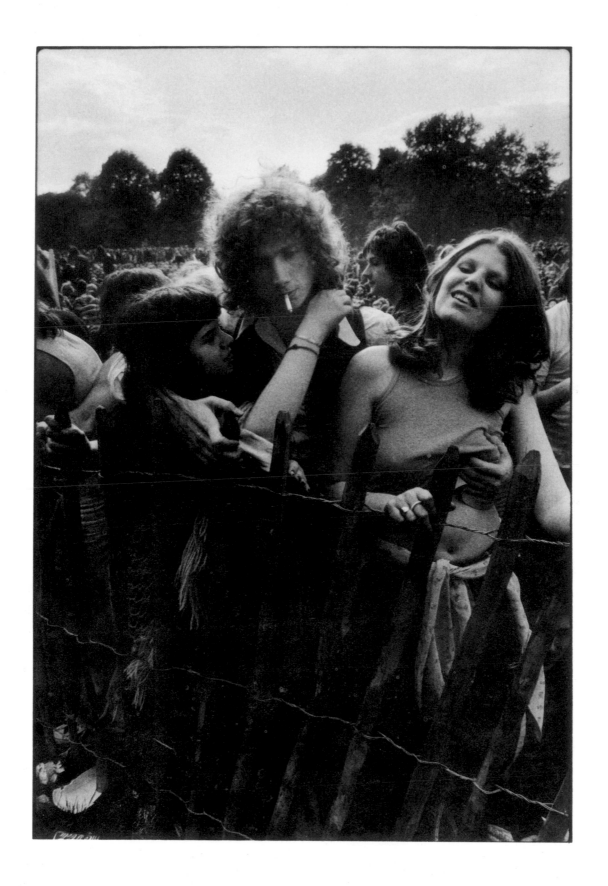

'M.C.P.'[1]

Cole Joseph is a taxi-driver. He lives in the old East End of London and as a hobby photographs its streets and the people working there. He uses an Instamatic camera and when necessary a flash-cube. The results can be brutally direct. His interests are primarily those of a collector, visiting places, snapping and filing away the chemist's prints in photo-albums as personal acquisitions. Joseph has little interest in exhibiting his photographs, but some were included in an exhibition at the Whitechapel Art Gallery in 1977 presenting different aspects of work and life in that area.

A number of people of differing sensitivity have photographed in abattoirs, butcher's shops and meat markets, but rarely do they produce work which so effectively throws up disturbing associations around the sinister activity of slaughter and dismemberment – a process transforming animals into meat, and suggesting the possibility that we are what we eat.

COLE JOSEPH 1975

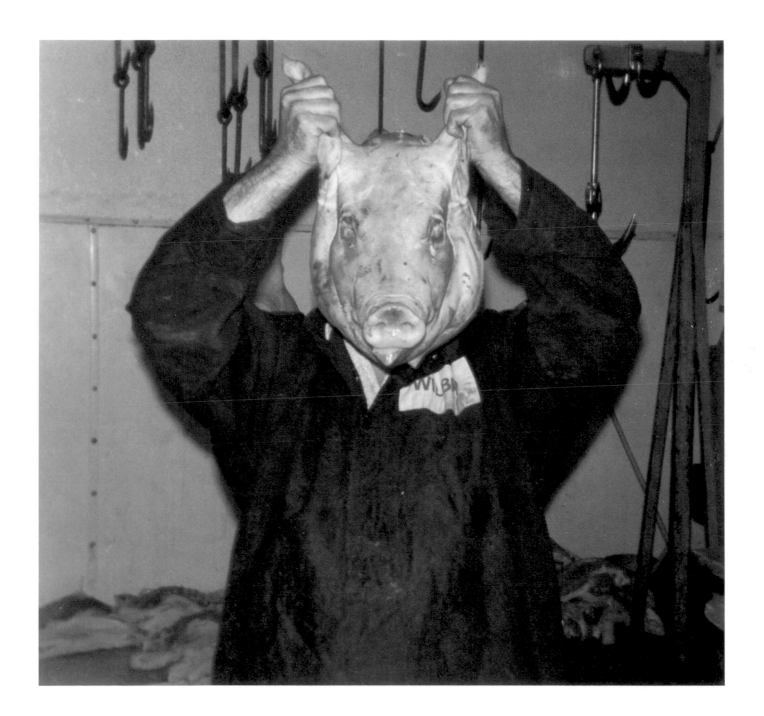

PINNER FAIR, MIDDLESEX

This photograph was taken at Pinner Fair, an event decreed by Edward III to take place twice a year: to celebrate the Nativity of St. John (1-3 June), and 'on the day and morrow of the decolation [beheading] of St. John the Baptist' (29-30 August). Originally a market for the exchange of cattle and produce, it has now developed into a pleasure fair which takes place in the High Street on Whit Wednesday.

Pictured is one of those situations where you pay to step inside a sideshow tent and watch ample women dance naked, before passing on to shy wooden balls at coconuts and win diminished goldfish in plastic, see-through bags. The master of ceremonies, in dinner jacket and bow-tie, has just drawn back the curtain to reveal his performers. All eyes are on them: including those of a decolated Humphrey Bogart and, of course, our own – voyeurs too.

HOMER SYKES 1971

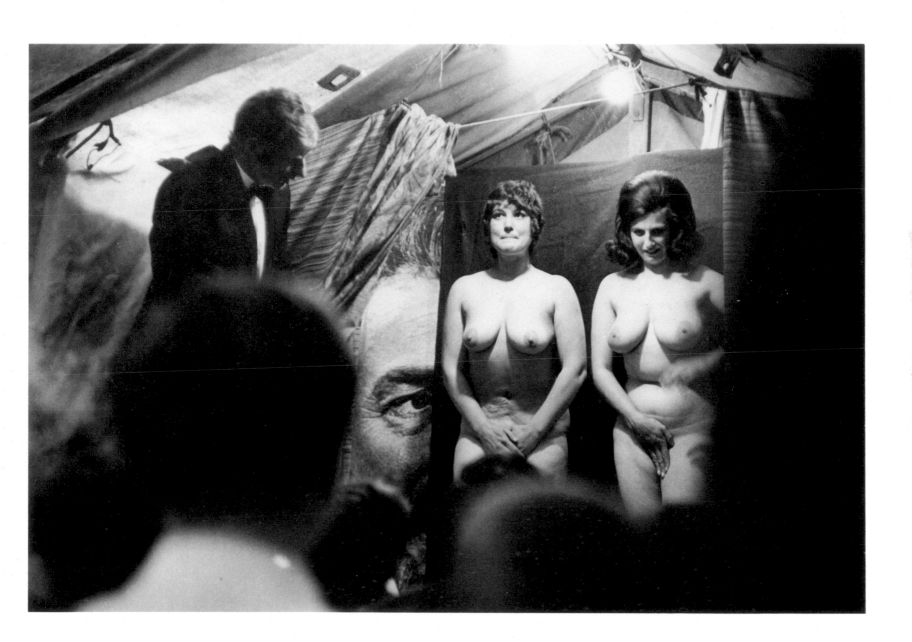

UNCLE CYRIL ARRIVING FOR TEA

Auntie Emma may be a bit fruity but it seems Uncle Cyril takes the biscuit. Grinning back at us from atop his BSA, he may well be saying he knows.

Michael Bennett made this series of montaged portraits as part of a whimsical exhibition in appreciation of his own family and once presented it at Brent Cross Shopping Centre.

MICHAEL BENNETT 1975

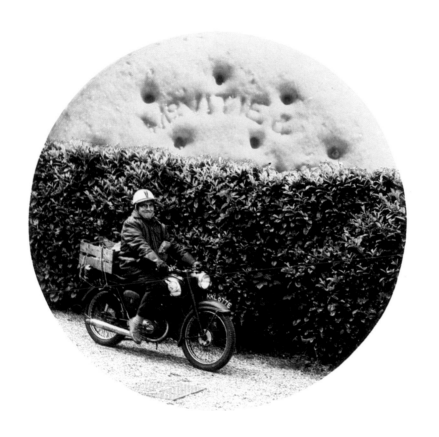

Most people use their cameras to record their family, friends, baby's birthday party, weddings, Christmas and holidays – the people and occasions closest to them. Many prominent photographers feature family members either in portraits or as models; yet it seems remarkably few professional reportage photographers attempt to photograph in detail their own daily lives and that of their immediate family, preferring instead to photograph slices-of-life from less familiar situations. Possibly this reflects the pressure imposed by working professionally militating against photographing the family with the same vigour and the fact that doing so is unlikely to be financially rewarding, since editors and publishers have not considered such personal work to be important. There is also the problem of including the photographer naturalistically as an integral part of the family.

Richard and Sally Greenhill are both professional photographers who decided to document their family life. Towards this end they rigged up a permanent bounce flash unit in their living room and made use of a radio-controlled shutter release on a camera which could be triggered wherever it was set up. Their intention was to record themselves as candidly as possible. They first showed this work as an exhibition called 'Family Self Portrait' in 1977.

Their daughter Nell was born at home with the help of a midwife in order that the birth could be more freely photographed and so that their son Sam could be present at the delivery. They felt that if he understood the circumstances surrounding the appearance of his new sister he would be less jealous of her, and in addition he might enjoy the experience. During the actual birth Sam got excited . . . but that was 15 minutes ago.

RICHARD GREENHILL 1976

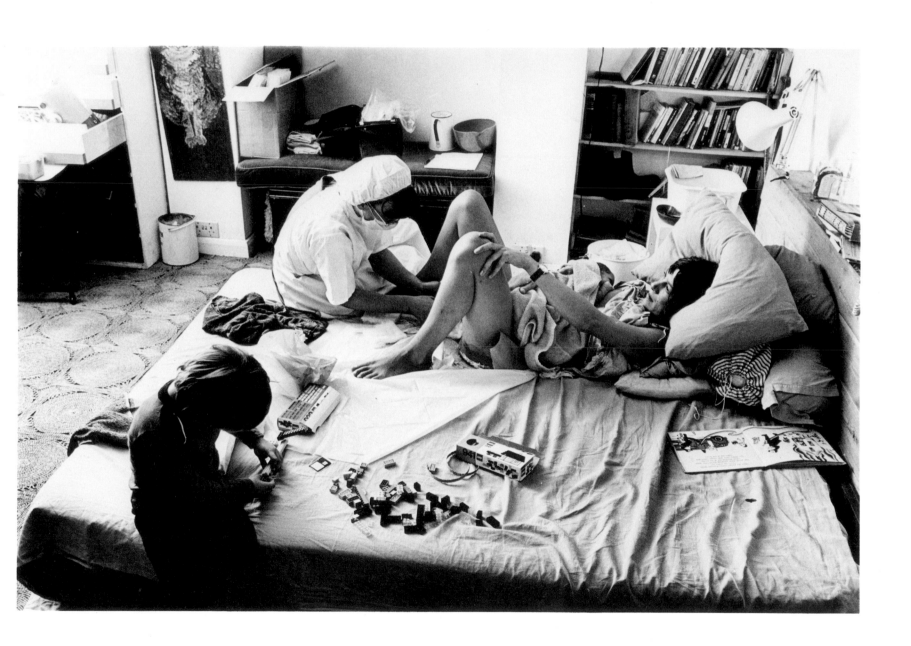

DESERT LOCUST IN FLIGHT Schistocerca gregaria

'This Desert Locust is in its darker migratory phase, ready to join with millions of its fellows and take off in search of greener pastures.'[1]

Like most scientific photographers before him, Stephen Dalton has had to develop the appropriate technology to achieve his particular purpose: to photograph with complete clarity insects in natural flight. This involved developing faster shutter speeds than any commercially available as well as an extremely powerful, short duration flash unit which could be triggered within one millionth of a second of a light beam being broken by an insect's motion. Such timing is necessary otherwise the insect would pass beyond the limited depth of field of the close-up lenses.

With the assistance of electronics scientist Ron Perkins, equipment was developed which could also record sequences. The photographs could then be used to study the changes in angle and movement of an insect's wings in free flight, a study necessary to determine how some insects fly in apparent violation of the principles of aerodynamics. Previously photographers had relied upon such unsatisfactory techniques as suspending the insect by thread.

Stephen Dalton's pictures represent an important breakthrough in the photographing of insects; they are also often astonishingly beautiful.

STEPHEN DALTON 1975

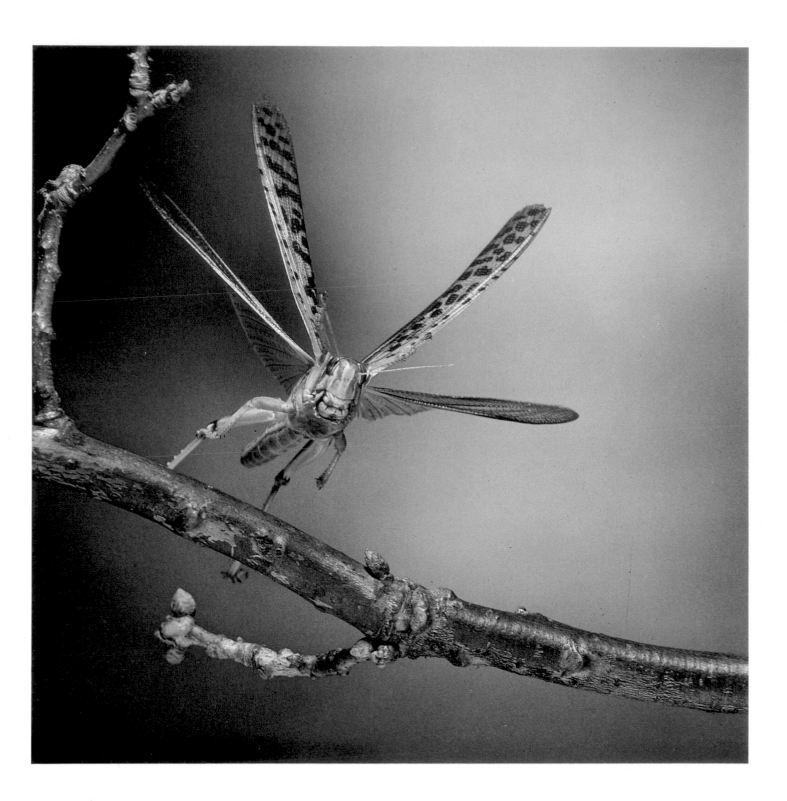

FIRE-EATER

Photographs all too frequently confirm predictable ways of seeing rather than advancing new ones. As with dossers, politicians, entertainers – indeed most sub-groups – stereotypes of people are easily adhered to. But when they are juggled, the effect can be potent.

Rolph Gobits plays on our expectations of show-business figures, with their associations of audience and role, glamour and lighting, costumes and smiles, by placing them in the mundane and professionally disassociated settings of private hallways and suburban living rooms.

Like an inversion of a tale of Cinderella having stayed too long at the ball, the costume remains but the surrounding splendour has vanished; the illusion stripped to its single human component, her theatre transformed for the photographer.

ROLPH GOBITS 1975

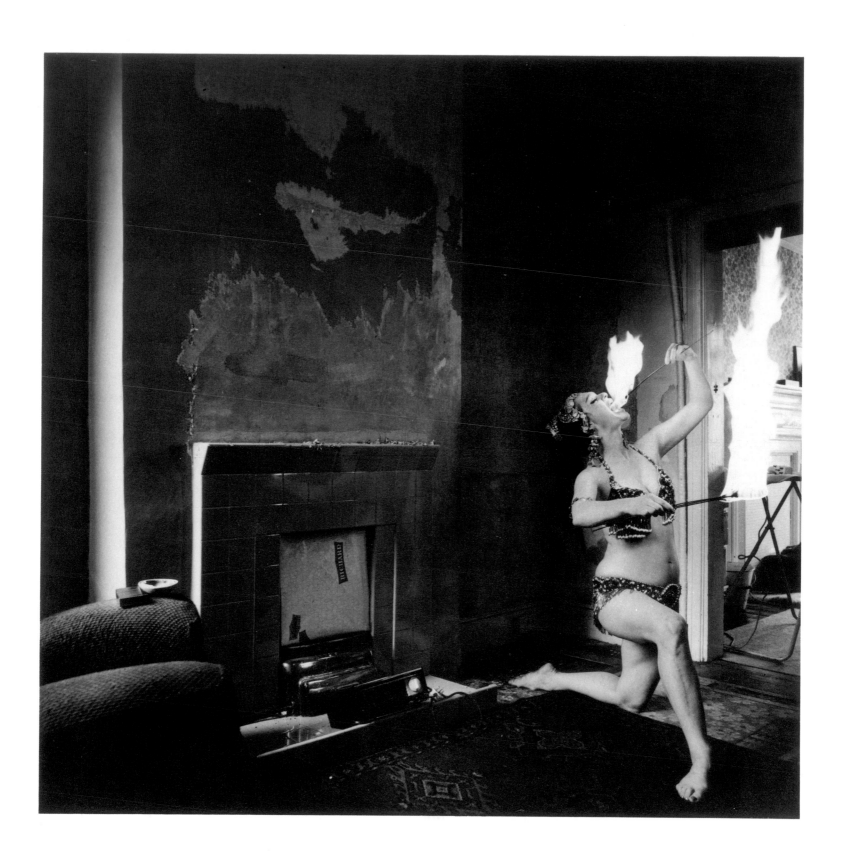

The role of the photojournalist is particularly subject to questions of deep personal responsibility. How much is a subject being used to advance the photojournalist's career, the readership of a magazine or a misconception of the facts or interests which may be detrimental and even harmful to the subject itself? Which of many possible photographic 'truths' does the photographer record: the policeman hitting the demonstrator or vice versa? Furthermore how truthful is the isolated photograph, as it is the caption which may ultimately interpret its meaning for us? And, more dramatically, should one act as a photographer in situations of danger or suffering to record, apparently dispassionately, in order to convey the information, or forego the photograph and attempt to intervene? Do you feed or photograph the starving child – or if both, which first? Many professional photojournalists would echo the sentiments of Peter Magubane, the black South African photographer: 'Whenever I find myself in a situation like Sharpeville [1960 pass-book demonstrations in which over 200 blacks were killed or wounded when police opened fire] I shall think of my pictures first before anything... It is only after I complete my assignment that I think of the dangers that surround me, the tragedies which befell my people.'[1] These questions are the specifics of larger moral issues which permeate all our activities, photographic, or otherwise but some situations bring them into pin-sharp focus. Their resolution is never simple.

During the war in Bangladesh such an event occurred. Bengali guerillas who had fought for Bangladesh's independence from Pakistan publically bayoneted a number of local Bihari prisoners accused of helping the invading Pakistani army. The act took place in a sports field in Dacca in front of a large crowd and members of the world's press who had been invited to attend. Some of the press, feeling that the event was being staged specifically for them, left, refusing to participate as witnesses. Some stayed, including photographers from Associated Press who where awarded Pulitzer Prizes for their photographs, and William Lovelace of the *Daily Express*, whose pictures later won a British Press award.

It has been suggested that if all the media people had left, the executions might never have taken place. It has also been stated that the executions were primarily for the local public and would have occurred regardless of the presence of the press. Undoubtedly, in the course of that war, other atrocities were committed which went unpublicised. But should that event have been recorded to tell the world what was happening, possibly bringing pressure to bear preventing further such acts? Or was it a matter of callous indifference to remain and photograph, possibly encouraging other barbarous demonstrations of power? If everyone had left might the guerillas themselves have photographed it?

At Dacca in 1972 William Lovelace decided to remain. As the crowd looked on and camera shutters tripped, a soldier in front of him stepped forward and plunged his bayonet into one of the captives. He repeated the action several times, even stabbing the man through his hands as they moved to protect his body. In this photograph the grisly spectacle has just begun. Most of the crowd have not yet seen what is happening. A few who have react. The other prisoners wait passively. Only one begins to realise the certainty of his fate. Seconds later, in another photograph, the effect of the dying man's scream will be seen on the faces of others; its look will still be frozen on his face.

You may have difficulty looking at this picture. You are similarly powerless to prevent its conclusion. But it is no use to point an accusing finger at Lovelace and say as some have done, 'Was it worth it?' Intolerable events of horror and inhumanity continue throughout the world, witnessed or not. You have seen the photograph now. The finger is pointing at you.

WILLIAM LOVELACE 1972

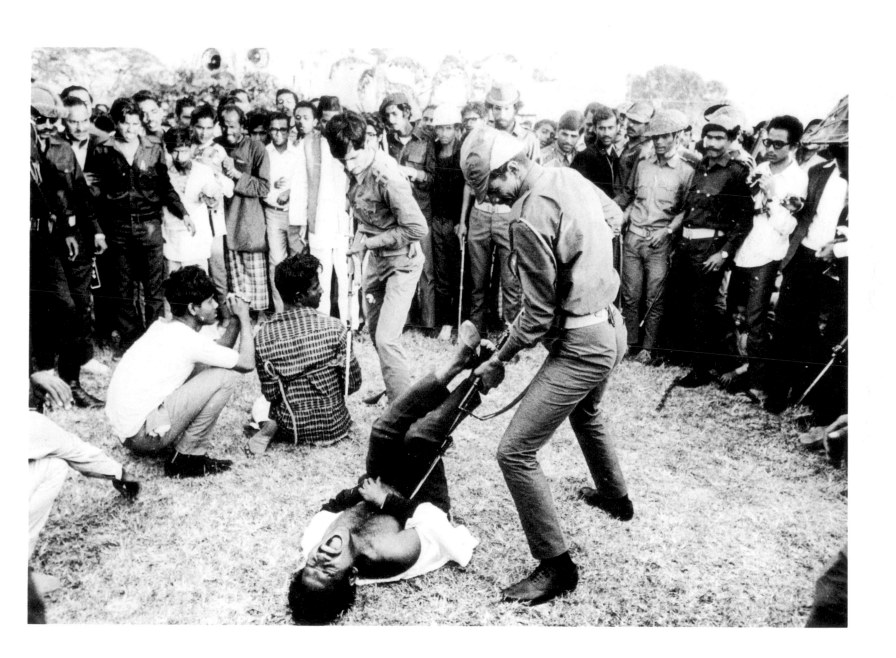

In the persistent battle for audiences the media will undoubtedly favour the horrific or heroic moment from a war situation; but it is often the apparent side issues which say things about the war that more ostentatious drama never can.

British troops have been in Northern Ireland for over a decade. Officially they are a peace-keeping force, but for many Catholics in Northern Ireland they are an army of occupation. The relationship between soldiers and civilians is complex and tragic; the task of the photojournalist in conveying it is correspondingly demanding.

The setting here is mundane – a corner of lawn, the edge of a pavement, someone with their shopping basket. The event is extraordinary. Momentarily the realities of power have been reversed and the soldier lies limp, impotent; a puppet held in check by a gesture. The identity of the civilian is not known, so that his foot may become anyone's foot, or even our own, an intervention representing the deepest wishes of a people.

After Philip Jones Griffiths took this photograph, his camera was opened by an Army officer in an attempt to destroy a picture which undermines the Army's image of itself. Because of this act it records not just an incredible situation but also, in the partial fogging the direct consequences of doing so.

PHILIP JONES GRIFFITHS

Photomontage is often used in a similar way to editorial cartoons, to symbolize, summarize and criticize. Recognizable elements can be assembled into more directly linguistic and exaggerated relationships than can often be achieved in straight photography.

Bob Long was a soldier in Northern Ireland and he makes explicit his feelings about the relationships there between Capital, The State and The People.

BOB LONG 1977

Some photographs have a knack of inviting their viewers into them. The invitation need not be seductive or even attractive. The reportage photograph couches its invitation predominantly in the actual physical space and situation photographed, rather than in the aesthetics of the picture; it must present a believable 'reality' to involve us effectively in its reportage.

Once we have entered Larry Herman's photograph we know we would rather not stay. The mood is depressing, resigned. Nothing is happening; there is nothing on the walls and nothing on the table to eat. There is evidence of psychological and physical battering, and there are the children. The photograph conveys the same sort of trapped feeling reflected on the face of the woman who looks at us, and probably for the same reason: it's a shitty situation and there is little either of us can do about it. We can leave, of course, just as we came in, but those photographed have no option but to watch us go.

There are few places of refuge in Britain for women who are beaten by their husbands or partners. The social pressures to remain with one's husband are enormous; ties of children and lack of institutional support mean that these women's situation is regarded as inevitable, if unfortunate. This attitude is reflected in the laws and the judiciary.

Recently, however, determined individuals and groups have persuaded some local authorities to provide anonymous housing for use by women as a temporary refuge, on the way to new accommodations in new neighbourhoods away from their spouses. They are not a solution, as relocation brings its own problems through separation from friends and family; but they fill a need that had previously gone unrecognized.

The severity of the problem is extremely difficult to determine. It certainly is not confined, as many people think, to working-class families. 25% of all reported violent crime is wife assault, and a recent report by a Government Select Committee on Violence and Marriage recommends that one refuge place be provided per 10,000 families, though National Women's Aid consider this to represent only a fraction of the actual need.

Undoubtedly, there are moments of pleasure and support among the women sharing such circumstances, or even just relief; but Larry Herman chose not to picture these and instead argues, convincingly, that the most accurate and meaningful perception of the experience of these women and children looks like this.

LARRY HERMAN c 1975

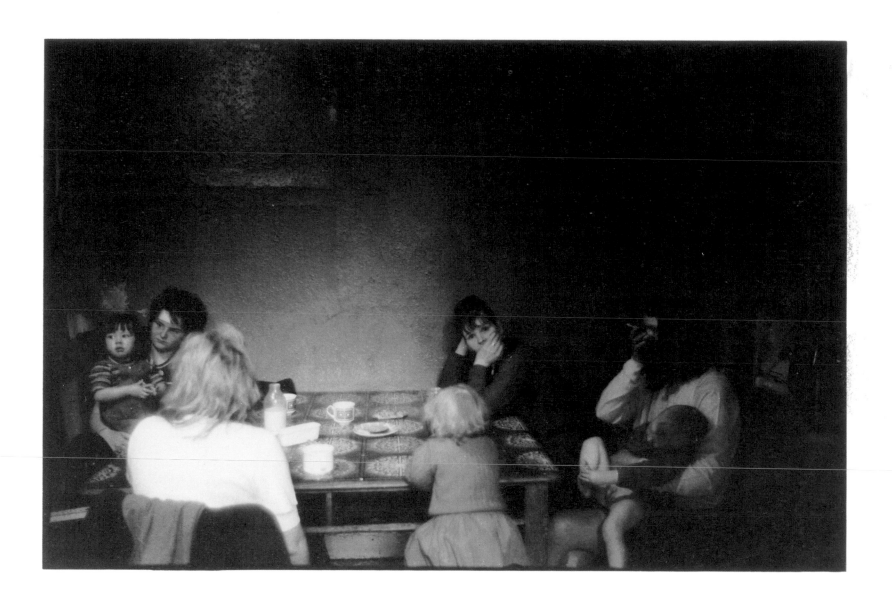

Women artists have a lot to say and many ways to say it that have not been possible before the major emergence of the Women's Movement of the 1970s. Feminism has provided a means of extending the issues, intentions, forms, subject matter – the nature of art itself. Its achievements could result in a radical shift in our awareness of what is valid or 'proper' territory not only for art, but for our attentions generally.

Annie Wright prefers not to be classified as a 'feminist artist', considering the label more restricting than enlightening. '. . . The "feminist art" I have seen in Britain has been openly polemical; in general, I don't think my work is, nor would I want it to be'. Regardless of this preference she has allowed herself to be presented as such, in sympathy with the role critic Lucy Lippard extends to feminist art of creating alternative ways of seeing beyond polemics. Wright also chooses not to call herself 'a photographer', but rather 'an artist using photography,' perpetuating cultural distinctions which are continually blurring and breaking down. This is done partly out of respect for the medium, acknowledging a lack of experience and expertise in photography formally, and partly in an attempt to avoid the prejudices and misconceptions that can still grow from expectations accompanying the photographer's stance in traditional fine art circles. But the work clearly exists as photographic prints, the final form she has found to be most effective for her ideas.

Annie Wright's title is a reference to the Freudian notion of the vagina as a 'wound' in the body of a woman's 'narcissism', caused by the absence of a penis.[1] The act of sewing itself is a natural, psychological, almost medical response to the large corporal gash through which her blood flows – an essential step in self-healing the psyche and attempting to prevent the 'scar' of 'a sense of inferiority' which Freud believed accompanies this awareness.

Wright's subject matter is herself:– 'My raison d'etre is being female, and all that implies in our society . . . I start a piece through some kind of basic impulse that makes itself clear in the process of making the piece. The sewing up was something I felt; I did not set out to illustrate Freud. It happened coincidentally . . .'

Her photograph combines a close intimacy of embroidery with the theatrical lighting of performance, and a stark, recordative black and whiteness, all translating her 'impulse' into a tangible reality. That which would normally flow out is now sealed in; and if fertilisation and impregnation have occurred . . . And if they have not . . . Unable to be strictly confined as woman's work, the piece has ramifications for its male viewers as well:– 'Feminism has given me a way of seeing things, analysing and realizing . . . I think the piece is about hiding, covering up and retreating – and, as has been pointed out to me, excluding'.

ANNIE WRIGHT 1979

Many visual artists have been fascinated by devastation and ruin. Familiar forms become dramatically altered; dynamic forces are visibly expressed, often magnificently. The attraction is apparent, although sometimes the deeper drama of which these surfaces are evidence, the actual human meaning of the events which have transpired to achieve them, seems lost and forgotten in the beauty of the form.

But new forms, to be recognizable, must in some way echo the old and these traces can be poignant. Depth of meaning, almost by definition, will not be found brandished on the simple surface of things. Photographers need not always pay conspicuous or even conscious homage to the more directly political, social or emotional implications of their work; the photographer's role as artist in a culture carries its own social and political reverberations and a built-in emotional involvement. The act of creation from destruction is itself one sort of homage.

MARTIN ROBERTS 1975

The Abbey at Bury St. Edmunds started life in 633 A.D. as a small community of secular priests, replaced in 1020 by twenty Benedictine monks on the orders of King Canute. Later its privileges and numbers were increased by William the Conqueror and it became one of the most powerful Benedictine monastries in Britain. Today, apart from two mighty gates into the precinct, all that remain are 'fragments, which tell their tale only to the student'.[1]

The place has become a popular stop for tourists. Countless postcards describe it. Untold numbers of Instamatics full of Kodachrome 64 have photographed it. Yet it seems unlikely that in any of those photographs it has ever looked quite like this.

It is a curious image, quite beautiful really, with amorphous stumps of crumbling stonework and a looming laval pillar liquefying in raking sunlight – an almost dream-like nether world caught in time as Nature reclaims these forms. Since in 'real life' matter seldom moves in such mysterious ways, we have arrived at two possible explanations for what is seen: it is actually a thoroughly ordinary setting, transformed by an audience who have collectively ingested some interestingly psychotropic drug or it is just one of those things that can happen whenever some place is well photographed.

CHRIS KILLIP 1973

The primary function of newspaper colour supplements is to act as vehicles for advertising; in order to do this effectively they must entertain. The majority of features are 'soft', easily consumable, and unlikely to disturb or offend the readership. Weightier photojournalistic articles are rare and are usually from foreign parts, relating less directly to our own culture and situation. Consequently they are less controversial.

It is of course difficult to draw a line between social responsiblity and entertainment, but advertising forces the issue. The pressure can be seen clearly if we consider the supplements in relation to commercial television. In television, advertising takes up a statutory maximum 10% of viewing time; in the supplements it seldom occupies less than 60% of the magazine's space. This means that even if an editor fervently wished it, it is most unlikely that supplements could become major vehicles for investigative, socially concerned photojournalism. This is a great shame because, through their massive circulation and considerable prestige, if the colour supplements were to adopt a more vigorously campaigning attitude they could certainly make a more valuable social contribution. Despite these limitations, many fine photographs are still made for the colour supplements.

David Montgomery has consistently worked freelance for the *Sunday Times Magazine* as well as being a highly respected advertising and fashion photographer. His photographs have the knack of appearing simple yet are more than mere illustrations, having a quality that might be described as understatement with flair, an unpretentious clarity and balance.

This picture of two retired English jockeys in a café was taken for a *Sunday Times* article on British influence in the French town of Chantilly, renowned for its lace, and horseracing.

DAVID MONTGOMERY 1975

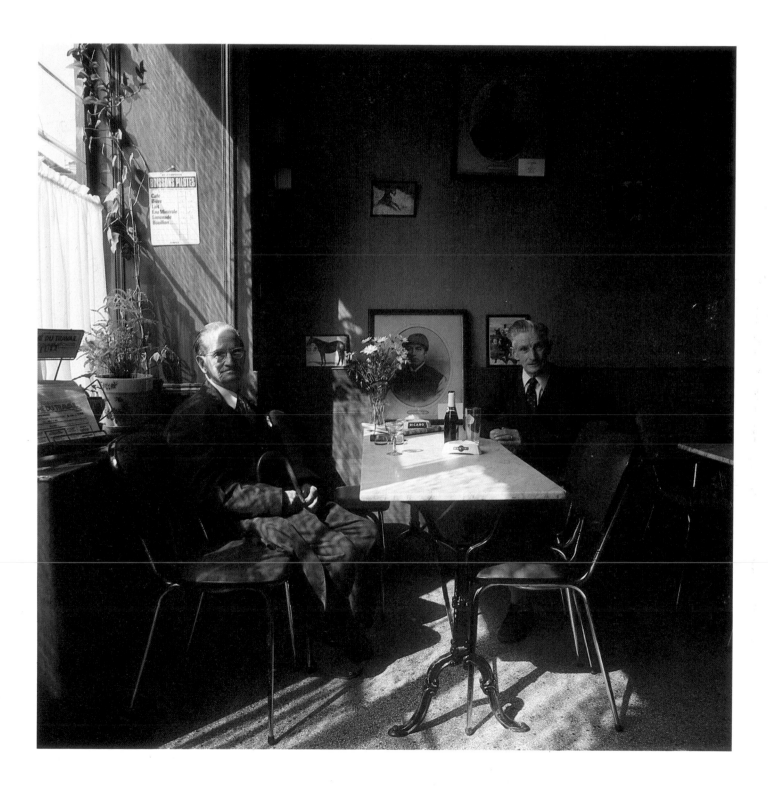

TIME WARP – FIGURE OPENING DOOR

Like a bizarre conundrum from a four-dimensional distorting mirror, a nude, female Uri Geller on Spyra Gyra legs bends open a solid door to effect her passage. The ordinary setting, direct light and apparent seriousness of the act all contribute to its believability; a convincing shadow on the brick wall 'outside' further enhances its presence. An impossible, surreal situation is momentarily made 'real' by virtue of the authenticity we ascribe to photography.

As a photograph it poses a number of questions. Is the woman leaving or entering the room? How is the door both open and closed at the same time? Why does the door open on to an undistorted brick wall? What is the significance of the lines at the top of the picture? Why is she wearing no clothes? There are only enough clues to permit plausible answers to some of these questions.[1]

Derek Burnett does not like to say how he makes his photographs. In fact, he effectively heightens their mystery with simple, flat statements meant to dispel it: 'The technique involved is not trick photography. Each photograph is from a single negative, using a standard 35 mm camera and lens'. He is even less revealing of his intent. The photograph is drawn from an experimental series, 'exploring the movement of an object through a defined space, still in the process of being developed'.[2]

DEREK BURNETT 1978

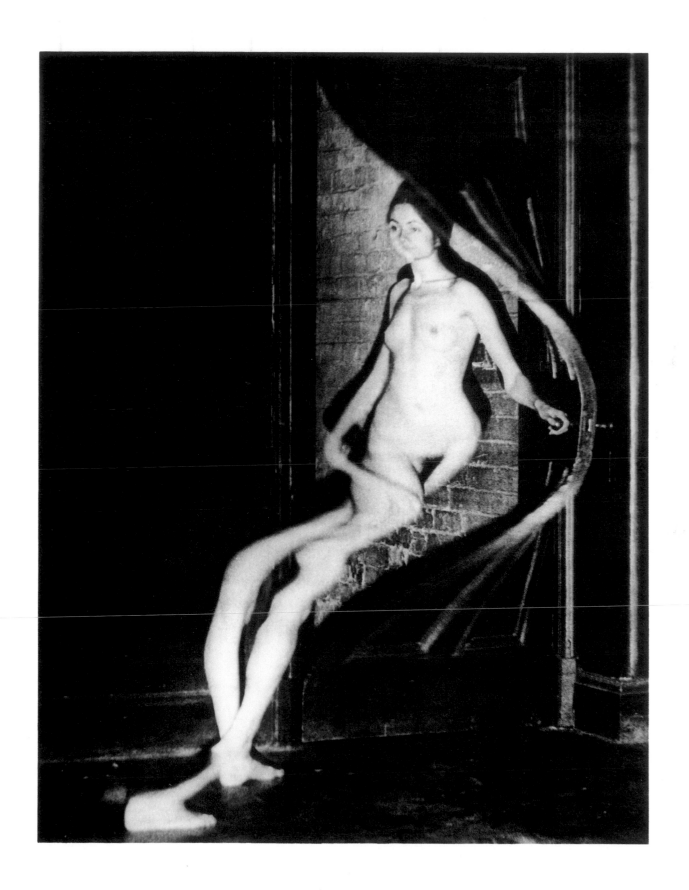

Client:	Decca Record Company Ltd.
Purpose:	album sleeve
Subject:	sheep and assorted live animals, 5 Rolling Stones, food, clock
Idea:	Mick Jagger
Meaning:	
Art Director:	sacked
Photographer:	Michael Joseph
Location:	house in Hampstead, property of Church Commission
Conditions:	£10 extra charge payable to Church Commission if naked women included
Equipment:	Hasselblad Super-Wide, 1 roll 2¼ inch black and white film, Kodalith paper
Aperture:	f.32
Subject response:	Jagger, 'knocked out'
Client response:	used for inner gatefold
Audience response:	over 1,000,000 albums sold world-wide
Cost:	£1,500
Waste:	60 sheets 10 x 8 inch colour film exposed on same set
Reason not used on cover:	typography used instead
Reason taken:	after the colour session, '. . . for fun'

MICHAEL JOSEPH 1968

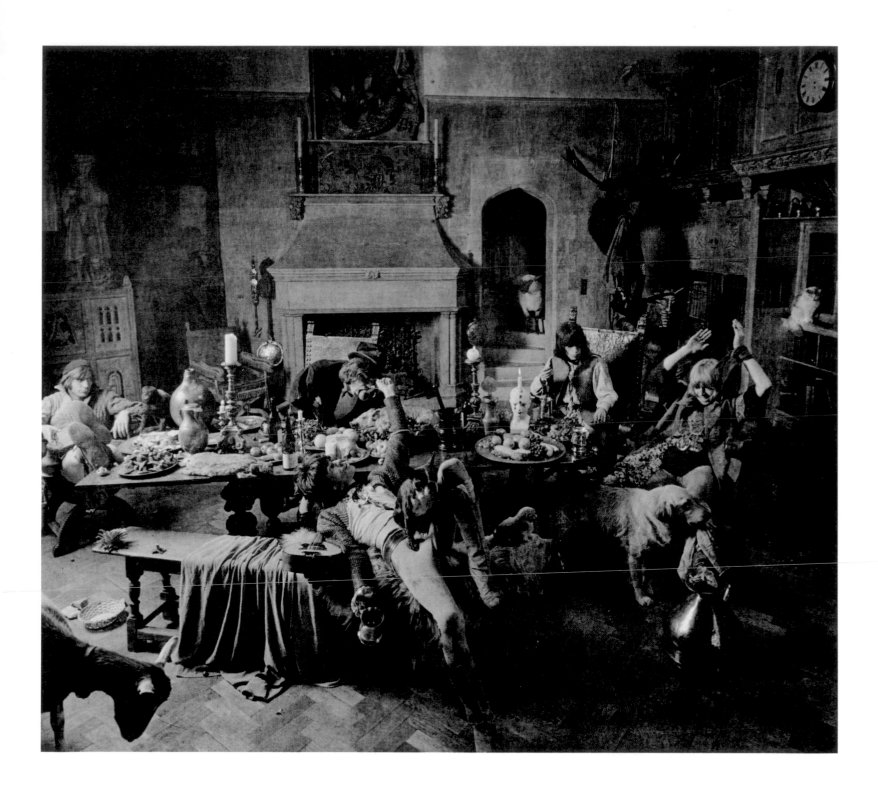

Valerie Wilmer lives in Balham ('Gateway to the South'), London, where she works as a photographer and writer.

James 'Son' Thomas lives in the heart of the Mississippi blues country. Until recently he supported himself and his family by grave-digging and working in a furniture store. He sculpts ashtrays, birds, skulls and portrait heads in local clay and earns a sporadic income from playing guitar in local bars and 'juke-joints'. The subject of a 45 minute, 16 millimetre documentary film made by the Memphis Center for Southern Folklore, he now plays at folk festivals and occasional college dates. He has also appeared on television in the state capital, Jackson, and has recorded.

Thomas plays electric guitar in the style of the noted Elmore James and his repertoire includes material recorded by James, Muddy Waters and Robert Johnson, three leading exponents of the Delta's haunting, ominous blues style. He says this of the blues:

'Lots of people haven't had no trouble, but if they're like me, they had nothing but trouble. And that's why I have the deep blues all the time'.

'The blues come from the country, and what the blues is made up about is women. If it wasn't for women, we wouldn't have no blues'.

'Just like at home if you and your husband having trouble, well he'd probably have the blues, and if he was a musician, he'd go out and make him a new blues up about it to give his heart ease'.[1]

VALERIE WILMER 1972

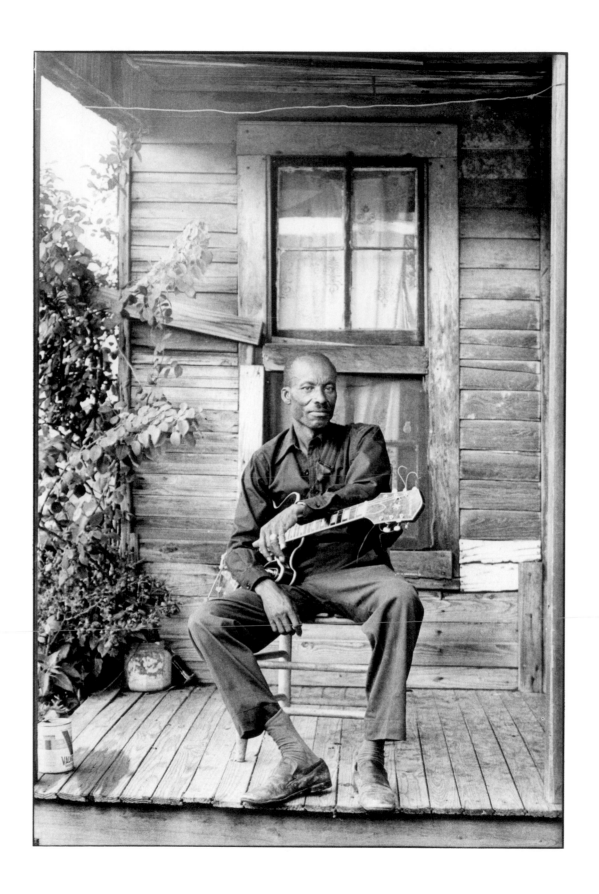

PUNK NIGHT AT THE GLOBAL VILLAGE

The photograph is part of a series documenting Punk, taken between January and March 1977 at two clubs in London.

'Our starting point was to get away from the candid documentary strategy ("the invisible, but truthful, hit-and-run photographer"), as well as avoiding the rough, grainy pictures associated with that method of working. We chose direct confrontation with our "subject-model" – this is why our pictures are posed – affirming our presence instead of eluding it. Working together enabled us to control lighting (flash, often off-camera), as well as being able to establish an easier relationship with our subjects. We attempted to achieve such a formal approach in order to emphasize Punk symbolism and to make it more readable'.[1]

The two photographers discovered this one-off cool, hydra-headed, pin-corrected, neo-Nazi dream-girl on heat and then made her picture.

KAREN KNORR AND OLIVIER RICHON 1977

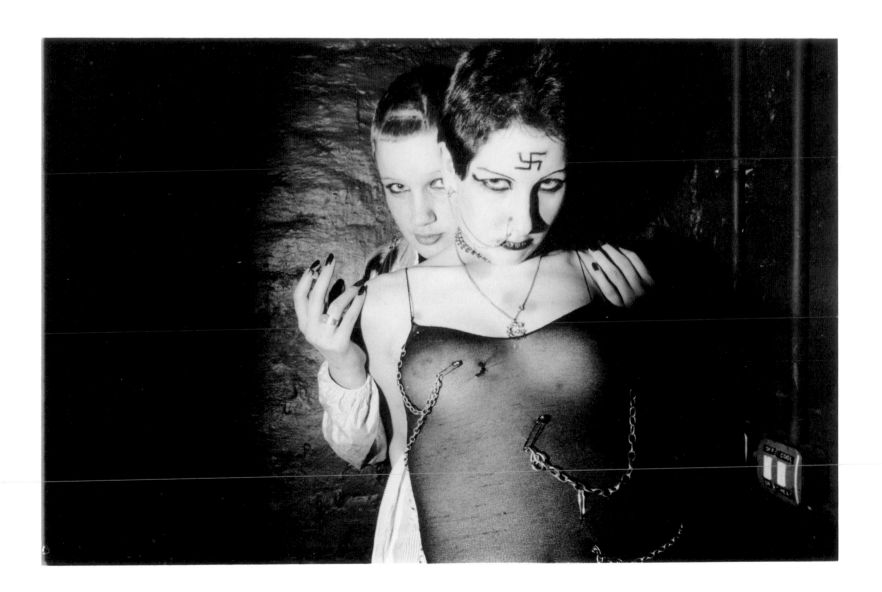

Whatever this is it has been constructed for a purpose. It is obviously hand-made from inexpensive materials showing little regard to finish; only what was absolutely necessary has been done. All of the bits are ordinary and familiar—almost any one of us could have assembled them. Yet, almost by design, the Insect Machine is disturbingly alien.

Wood planks and pressed sheets form its skeleton and skin. The joints are metal hinges which have been placed once, then removed and reset. The screws have been inserted roughly, from various angles. Small nails are driven into a crosspiece sufficiently deeply to hold down something which is no longer there, and every second nail is missing. Nuts and bolts have been used; at least one pair of these is gone. Other vacant holes attest to further disappearances (perhaps a change in function necessitated an adaptation).

Part of the thing's function is electrical and of low voltage, relying on two small dry-cell batteries. The wiring is not well wrapped and compacted but rather a confused conjunction of worms, springs and alligator-jawed clips feeding a fluorescent-type fixture.

Placed within the contraption's interior and supported beneath the huge and haphazard visual and psychic weight of its structure, there lie, on a thin, raggedly torn slip of white paper, the bodies of two incapacitated or deceased insects—the probable point of the machine's existence . . . and the only things perfect on this incredible monument to human resourcefulness and lack of grace.

It is also Locusta Migntona and 5th instar proposed for study under UV light after spraying with insecticide.

GLENDA A. COLQUHOUN 1974

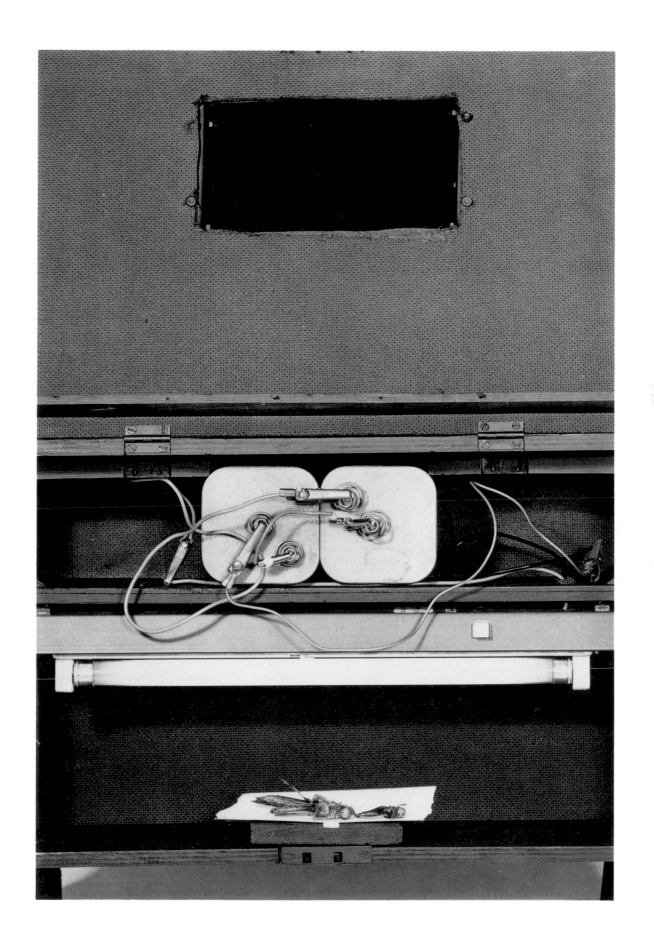

In Victorian Britain posed photographic tableaux were popular. Julia Margaret Cameron and the partners D. O. Hill and Robert Adamson enjoyed posing friends and acquaintances in costumes of varying degrees of absurdity (armour, veils, Greek robes, monks' habits) to produce anything from stylized portraits to re-enactments of classical themes; while O. J. Rejlander and Henry Peach Robinson employed elaborate combination printing techniques to achieve their allegorical tableaux in imitation of Victorian genre painting.

Later in this century the tradition of the dramatic, stylized portrait continued to be refined in the work of Cecil Beaton, Angus McBean and Bill Brandt, while the posed tableaux passed into the province of advertising, producing contemporary fictions on such themes as the bravado released by a box of chocolates, or the social kudos imparted by particular soap powders.

Boyd Webb makes use of the allegorical style of the Victorians and the absurdity often underlying advertising; but, whereas both those forms have specific intents, his are deliberately oblique – some narrative appears to be unfolding, but its meaning does not.

Two men are apparently concerned to understand something about the forms of elephants' trunks, presumably the difference between that of the Indian and African elephant. The caption directs a plausible reading without increasing our understanding, underlining the basic fact that photographs, while describing everything, do not necessarily explain anything.

Our normal perception of photographs is that they are true and self-evident; our expectations, however, often include the convention of captioning. We require that the meaning of a captioned photograph be as readily available as the words are readable and the subject matter recognizable. We are conditioned to this belief by the use of the news photograph and the advertising image, both highly directed and purposeful modes.

Photographs are, in fact, ambiguous fictions; they rely heavily on familiar associations and words to validate their meaning. Captions may resolve any questions we have. In the news media they are used to define an event which the photograph then confirms as fact; in advertising they are meant to convince us of a need which can be filled only by what is pictured. In both instances the captions spell out the understanding intended.

Boyd Webb reverses this process, which ostensibly resolves the photograph's ambiguity, by choosing captions which confound. The specifics of the photograph reveal nothing to help us, though initially they would appear to be our key to a resolution. Consider the same caption applied to other photographs in this book (try it with those on pages 15, 81, 93, 103 or 131). Picture and caption are a reciprocal, enigmatic system.

Photographs are particularly suited to this usage as they so often clearly resemble something, but that is not what they are.

This photograph is only art. It was made in an art context, for art's purposes, to sell itself in the art market-place. It is the product of an ongoing, self-referential, partly state-supported industry, attempting, as with advertising, to convince us how much we need what it provides and, as with news, defining its own existence while confirming it as fact. It is a tenuous existence, but sustained by its believers it has meaning and worth. Of course, as with the diagnostic sciences or selecting a tie, second opinions are mandatory.

BOYD WEBB 1978

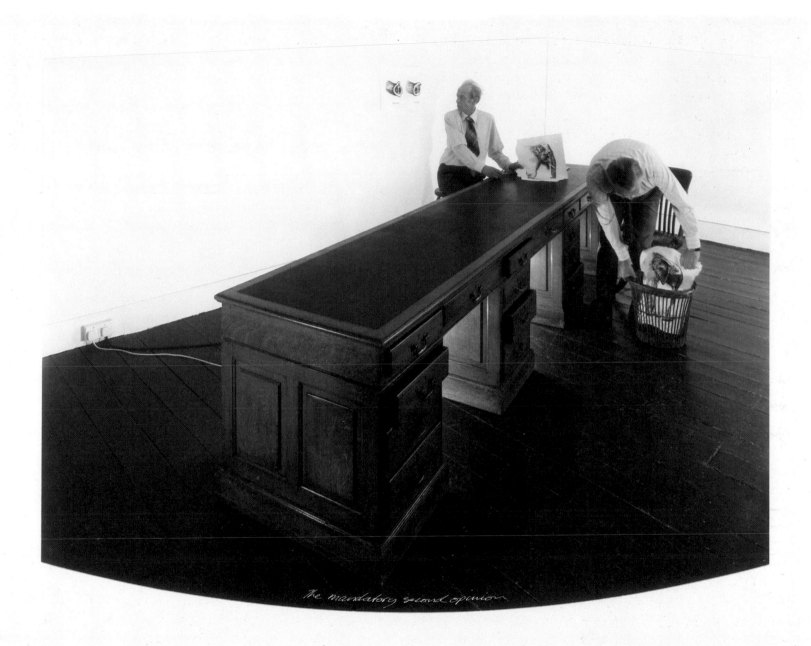

The mandatory second opinion

132 JUMBO HELPS

The ultimate test for a photograph is that it be a sufficiently plausible fabrication to function as truth.

JOHN DRYSDALE 1978

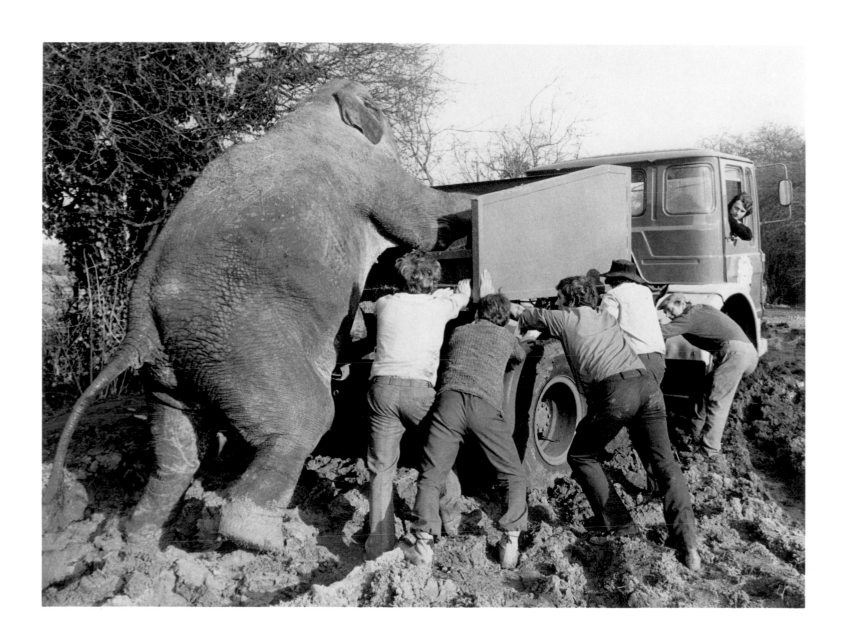

From the grainiest and fuzziest to the most seamless and detailed, there is a look to photographs that immediately identifies them as *photographs* – camera-made pictures. In contemporary 'fine photography' the prevalent look is sharp, clear, fully tonal and precisely bordered; yet the photographic process is varied and plastic and may be regarded equally as a print-making medium and as a recordative one.

This picture is a photograph made from a normal negative using a gum bichromate and pigment emulsion process which has the property of becoming less soluble in water the longer it is exposed to light. After exposure through the negative the paper is washed in warm water in order to 'develop' it, dissolving the less exposed areas. The process is extremely amenable to manipulation: recoating, selective washing etc. For this reason, and the fact that it was used at the turn of the century to imitate Impressionist painting, it has been heavily criticized. The prominent English photographer and critic, Peter Henry Emerson, attacked it as impure photography and fake art. Of course, the notion of a 'pure' photography is suspect as virtually any photograph requires some degree of manipulation. The American photographer and impressario Alfred Stieglitz was more astute on this issue: 'The result is the only fair basis for judgement. It is justifiable to use any means on a negative or paper to attain the desired end.'[1]

This photograph was made to record the circus. It has been printed in this way not to imitate turn-of-the-century art but as a reaction to the look of current photography, exploring an alternative to the silver print in presenting the photographic image.

MARI MAHR 1976

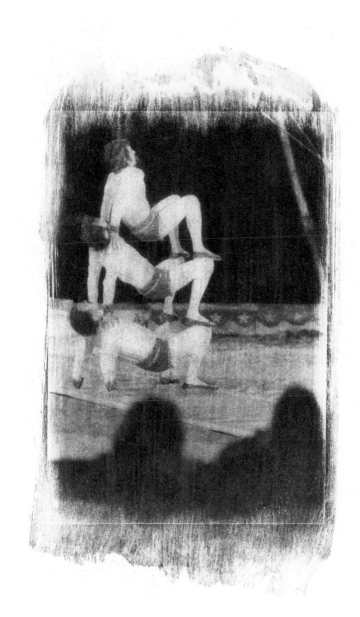

Plan Bland '76

This photograph should warm the cockles of an ageing Cubist's heart, representing as it does all the surfaces of its subject simultaneously in a single plane. Attempts to do this have been made since the early days of photography. A Cyclograph designed by one Arthur Hamilton-Smith, Keeper of Greek and Roman Antiques at the British Museum, was reported in the *Journal of the Royal Photographic Society* (Vol XIX) in May 1895. Various other techniques have been developed; but the latest and most flexible means of accomplishing this with one negative is the R. E. Periphery Camera.

The result is obtained by rotating the subject in front of the camera while a thin slit, which 'sees' only a sliver of the subject, moves, electronically synchronized, across the film plane, laying down a continuous photographic image – the optical equivalent of an inked printing cylinder turning across a page to leave its imprint.

Because of limited depth of field, the camera's greatest usefulness is in photographing cylindrical objects. It can be of assistance in areas such as archaeology, when a photograph of a rare item, showing all its surfaces, may be sent in lieu of the thing itself. The current practical usefulness of photographing human beings in this manner is dubious; future applications, however, may be imagined (e.g. in criminology, diagnostic medicine, etc.).

The photograph is of Mr Freddy Fox, appropriately the designer of the R. E. Periphery Camera and apparently cylindrical.

FREDDY FOX 1967

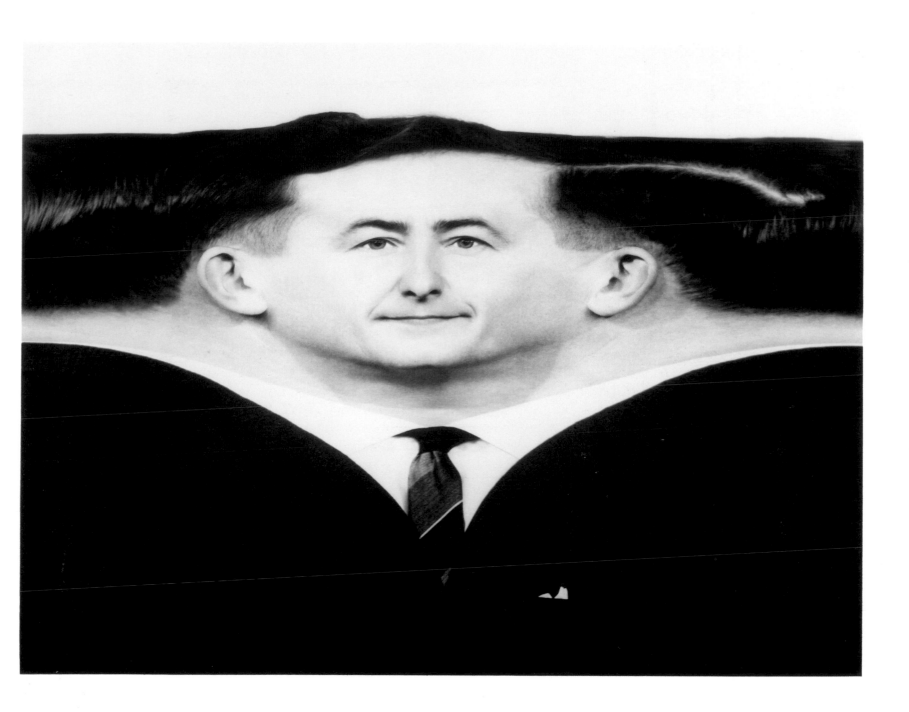

Advertising photographs are among the most ubiquitous and costly of all photographic images. A national poster campaign can ensure that, with the exception of the monastic, the imprisoned, the bedridden and the blind, virtually everybody in the country will see the photograph promoting the product. More than £20,000 may be spent on a single photograph even before posters are printed or media-space purchased. Such work is often manipulative, socially discriminatory (classist, sexist, racist) and technically superb. As imagery it is also frequently dull, a form of visual effluent that enters the consciousness solely by virtue of blanket exposure.

The Benson and Hedges 'Special Filter' cigarette advertising campaign has produced a more interesting set of photographs, the most successful of which rely largely on exploiting ambiguity. In an intriguing and entertaining way they explore ideas about photographic representation, playing with different means of disguising the product instead of simply thrusting it in front of us. The only caption is the statutory government health warning; we are encouraged to examine the image to discover the product's identity/ies. The success of the campaign relies on the viewer being sufficiently intrigued to enter into this game and recognize each new poster as 'another Benson and Hedges ad'.

In a photograph like this – where the mirrored packets transmute to plaster ducks (an oddly down-market reflection), values reverse and realities shift; the cigarettes are clearly not what they seem. An embedded implication is that we are being offered an alternative experience, an unusual hallucinatory reality . . . not carcinogenic death.

ADRIAN FLOWERS: Photographer 1978

GRAHAM WATSON: Art director

GUY HODGKINSON: Set builder

The contentious issue of subjectivity in photography is perennial. In the medium's early days it gnashed its teeth on the relationship between photography and Art. If photography could indeed be subjective then it was argued it could also be Art – but if purely mechanical then it obviously could not be.

Since those days the stubborn monster of subjectivity continues to raise its head in various forms, while the tedious Art/Photography debate drags on. The most publicised recent (though not actually new) formulation on the matter created the categories Mirrors and Windows[1]: Mirrors reflect the individual reality of the photographer and therefore look inward, subjectively, while Windows look outward to describe the external, objective world. The concept has the seductive reasonableness of assertions like 'Every picture tells a story' and 'The camera never lies', but its usefulness is just as suspect. Neither category is absolute. All photographs are to some degree Windows and Mirrors. Cameras record; human choices determine how. But how is this dimension to be scored? What criteria are used to decode a photograph for meaningful objective and subjective content?

Subject matter is a tempting guide: trees, rocks, nudes, clouds and abstract forms have all come to be identified with a personally reflective intent, yet they are only categories of recordable material, with no special claim to be interpretative.

Image quality is another, as fine quality may be associated with care and, by extrapolation, personal involvement and hence subjectivity; alternatively, it may be a blind obsession with photographic technique as a substitute for content.

Mastery of the formal organization of the picture may suggest a desire to say something with that ability or may merely be an indulgence in visual gymnastics.

Stage-managed photographs deal with a fabricated rather than found reality, a world which can be created in the recesses of the photographer's imagination. Yet their most frequent use is in advertising, where they are usually made to an art director's specifications for a client's selling requirements, with the photographer playing a subordinate role.

Unusual photographs may reflect an unusual mind behind the camera transmitting a 'personal vision', but the quality may also be due to our own unfamiliarity with their subject matter or some recent pictorial fad (e.g. blurring, tilting, daylight flash, decapitation, inversion, etc.).

Titles and captions accompanying photographs may well indicate how the photograph is meant to be seen, but knowledge of the photographer's intent is not sufficient for a meaningful understanding of the image if the photograph itself is not a successful collaborator. While added words can give a context in which to read the image they are not a substitute for content and can even be at odds with the photograph's purposes and capability. Furthermore, many photographs have only nominal titles or none at all, and offer no verbal clues to their relative subjectivity or objectivity.

The public stance of the photographer can be considered as well, as some individuals make claims of subjectivity for their work while others plead objectivity, and this may affect the way we approach the work (though, again, claims and photographs may disagree); yet those who make no such statements may, in practice, operate with equivalent concerns.

And there is the unpredictability of the viewer, whose frame of reference may be far removed from that of the picture-maker and whose responses will flow from a personal set of experiences, meanings and symbols. The photograph lives in this interaction and its ultimate meaning – subjective and objective – is here, to some extent, thrown up for grabs to be redetermined and defined as you choose.

All these proposed criteria for isolating or measuring subjectivity in photography ultimately fail. There is no question of photography's role as a primary twentieth century art; what is important is recognizing that precisely the functional presence of both objective *and* subjective concerns make photography so effective a medium.

This makes the equation nearly complete: the camera records and human choices determine how. Human choices also decide what to make of the result. But there is still one missing factor, continually affecting the outcome.

We should like to draw your attention to the photograph to the right. It represents the final quantity, the extra dimension of Chance. It is an accident, one of the waste exposures on a roll of 35 mm film as it is loaded into the camera and advanced to 'frame 1', the point at which picture-making is consciously intended to begin. And so, as chance would have it, it has virtually nothing to do with any of the things we have been discussing here.

PHOTOGRAPHER IRRELEVANT [2]

'Nuclear particle physicists are searching for the secrets within the heart of subnuclear matter in an attempt to understand Nature herself. These physicists produce beams of high energy particles and fire them at various targets. By studying the "fragments" which are produced in these energetic collisions, it is hoped to piece together the highly complex jigsaw puzzle of life.'[1]

This is the calligraphy of subnuclear physics; the signs that must be decoded to learn their meaning. It is a photograph of the inside of a 'bubble chamber' containing a mixture of liquid hydrogen and neon maintained under pressure. A beam of neutrino particles enters from the left. The paths of the charged particles produced by a collision are made visible by lowering the pressure of the chamber, causing bubbles to form along their tracks. A magnetic field acts over the whole chamber, causing positive and negative particles to bend in opposite directions. Uncharged particles, including the neutrinos themselves, are not visible; but some, such as gamma rays (dotted in drawing), are visible when they change into oppositely charged electron pairs . . . as seen in the photograph.

Thousands of such photographs are taken, and tracings made of the significant information. At the same time the photographs can be scanned automatically and the results fed into a computer for detailed analysis of each interaction. The problems of arriving at this particular photograph are enormous; neutrinos are remarkably elusive. Indeed, their mass at rest is theoretically zero. They interact with matter most infrequently: only 1 in 10^{10} (100,000,000,000) that pass straight through the Earth is likely to meet a particle. With an estimated 10^{14} neutrinos from the Sun passing through our bodies every second, only one neutrino interaction will occur in a lifetime.

The world of subnuclear physics is one of statistical probabilities, leaning on chance for the meaning it yields. It seems appropriate that the last photograph in this book serves as the interface between a chance event of which only the recorded traces can be seen and an effort to 'piece together the highly complex jigsaw puzzle of life'.

But if that does not seem appropriate to you, consider this: if all of you spend the next two weeks carefully perusing this book, one of you should have a neutrino interaction.

RUTHERFORD LABORATORIES 1978

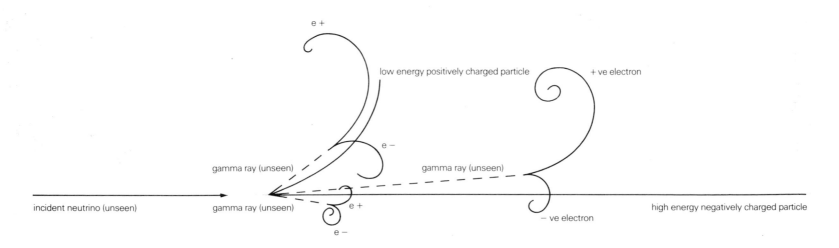